IMAGES
of America

VASSALBORO

On the Cover: Until 1975, the Methodist church was split into two buildings, one in North Vassalboro and one in East Vassalboro. At this time, Pastor Robert E. Cumler (who oversaw both churches) held a meeting of churchgoers in North Vassalboro to discuss merging the two churches. This vision was not realized until 1980, when members of the churches finally voted to merge. The names of the East Vassalboro Methodist Church congregation in 1912 are available at the Vassalboro Historical Society. (Courtesy of Vassalboro Historical Society.)

IMAGES of America
VASSALBORO

Vassalboro Historical Society

Copyright © 2025 by Vassalboro Historical Society
ISBN 9781-4671-6190-9

Published by Arcadia Publishing
Charleston, South Carolina

Printed in the United States of America

Library of Congress Control Number: 2024941631

For all general information, please contact Arcadia Publishing:
Telephone 843-853-2070
Fax 843-853-0044
E-mail sales@arcadiapublishing.com

Visit us on the Internet at www.arcadiapublishing.com

This book is dedicated to and wished for by Julianna Lyon, one of the greatest treasures connected to our society. Her workmanship is seen everywhere.

Contents

Acknowledgments		6
Introduction		7
1.	Vassalboro Historical Society	9
2.	South Vassalboro	11
3.	Center Vassalboro	13
4.	East Vassalboro	29
5.	Getchell's Corner	67
6.	North Vassalboro	73
7.	Oak Grove	109
8.	Riverside	113
About the Organization		127

Acknowledgments

The Vassalboro Historical Society would like to acknowledge and thank the many amazing volunteers who have contributed to this project: Julianna Lyon confirmed information or pointed us in the right direction; James and Vicki Schad researched and wrote captions; and director Dawn Cates and Sharon Hopkins Farrington went through our many photo albums to find the images for the book. Ashley Cyr, our curator, worked on all parts of the book doing research, writing captions, and selecting photographs. Treasurer (and IT expert) Laura Jones lent us her scanner, which allowed us to scan the images easily and in the correct format. Our long-term building director, David Bolduc, took pictures of people and activities throughout the years and gave them to the society. We also thank spouses and children who have been willing to lend a hand. We would also like to thank our members, who have contributed financially through their memberships and by their donations of Vassalboro items, including most of the photographs shown in this book. All images in this book are from the Vassalboro Historical Society collection.

We continue to make progress in improving the society with the guidance of our board of directors: president Jan Clowes; vice president Raymond Breton; secretary Dondi Dexter; membership secretary Simone Antworth; and directors Russell Smith, Douglas Phillips, John Melrose, Stewart Corson, Suzanne Griffiths, Samantha Lessard, and David Theriault.

Introduction

The town of Vassalboro is comprised of several distinct and indistinct areas. This book highlights the six specific areas of North Vassalboro, East Vassalboro, Center Vassalboro, South Vassalboro, Riverside, and Getchell's Corner. These locations do not sufficiently capture roads such as Route 201, which winds from Winslow to Augusta through Riverside and Getchell's Corner, or the intersection of Taber Hill and Hussey Hill Roads, leaving the residents of those areas to determine for themselves which area they belong to. Some roads, like the Legion Park Road, are located in Vassalboro but we have few pictures to document them.

Names have continued in Vassalboro from the earliest settlers, including the Kennebec (also known as the Kennebees or Kinaibik) and Natanis, from the Wabanaki tribe, who, according to *The History of Vassalborough, Maine* by Alma Pierce Robbins, "was the first of his race to shed blood for the cause of American independence." Other names from the earliest settlers include Getchell, Smiley, Priest, Jones, Rogers, Brown, Robbins, and Webber. Others who came later and who were no less important to our town were the Taylors, Lampsons, and Husseys. Their properties were left to the society and include, from Ina Hussey Weymouth, Ina's Barn; from Elizabeth "Betty" Taylor, her family home and blacksmith shop; and from Annette Davis Lampson, her father's harness shop.

Businesses have come and gone, but imagine the busy mills and the transportation which was used to get there. It may have been horses ridden to the local sawmill or the trolley to the American Woolen Mill. The economy of our town was booming with businesses in the 1800s and early 1900s, including mills that made shovel handles or shingles, millinery shops, boot makers, lawyers, doctors, asheries, sculptors, clock makers, and violin makers.

At one point, there were 23 schools in Vassalboro, including the beautiful Oak Grove with its castle-like buildings and its chapel. Now serving as the Maine Criminal Justice Academy, it remains a significant sight in our town, with a great view of it from across the river in the town of Sidney. Created as a Quaker school, classes began in 1850. Although it started and ended as a coeducational school, in 1918, it became an all-girls school under the leadership of Robert and Eva Pratt Owen. In 1971, it merged with Coburn Classical Institute to become Oak Grove–Coburn, closing in 1989. Oak Grove and Oak Grove–Coburn alumni include author and poet Holman Day, actress Estelle Parsons, actor Titus Welliver, editorial cartoonist Greg Kearney, civil rights lawyer and professor Michael J. Steinberg, and musician Ilene Barnes.

With beautiful lakes, ponds, and streams, there were cottages and campgrounds on many shores. The Union Camp Meeting, the Cottages at Pleasant Point, and Green Valley were just a few of the popular places. There were many churches, including Baptist, Catholic, Congregationalist, Full Gospel, Methodist, and the Society of Friends. Due to travel issues by horse and buggy, churches were in multiple areas to make it easy to attend. The Union Meeting on Webber Pond Road was started because there was no church on the road. It served as a multidenominational church for nearby residents if the worship was Christian in nature.

Organizations that served the community included the Grange. There were three, but now only one remains. The Grange in East Vassalboro is still very active. The Masons continue to meet and serve the community from their lodge in North Vassalboro. The American Legion is still active, as are Scout troops. Various other groups came and went, including the Maine Agricultural Society, which was formed in 1787 and is no longer in existence in town; the Browning Club; the Christmas Club; Riverside Corporation, which later became the Riverside Study Club; and the Maccabees.

Although there have been lots of changes in all areas of Vassalboro, it remains home to nearly 4,500 residents. Our residents have an assortment of activities to participate in thanks to the Mill, St. Bridget's, the Grange, the Vassalboro Public Library, Vassalboro Trails, Vassalboro Town Parks and Recreation Department, and last but not least, the Vassalboro Historical Society, where the past meets the present. Please stop by and browse our displays and research families, businesses, and buildings. You can look for past events in our indexed scrapbooks of newspaper clippings, browse our photo albums, or play our piano or pump organs. Many captions are original and do not refer to the current day. We can't wait to see you.

One

Vassalboro Historical Society

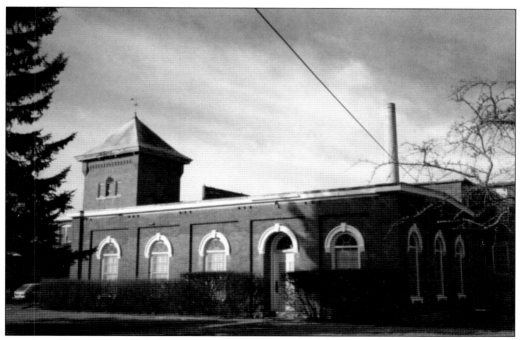

The Vassalboro Historical Society was incorporated in 1963. After starting its meetings in members' houses, it moved to an office building owned by the town on July 11, 1963. The American Woolen Mill was still being used as the society's museum while readying the old East Vassalboro Grammar School for displays and storage.

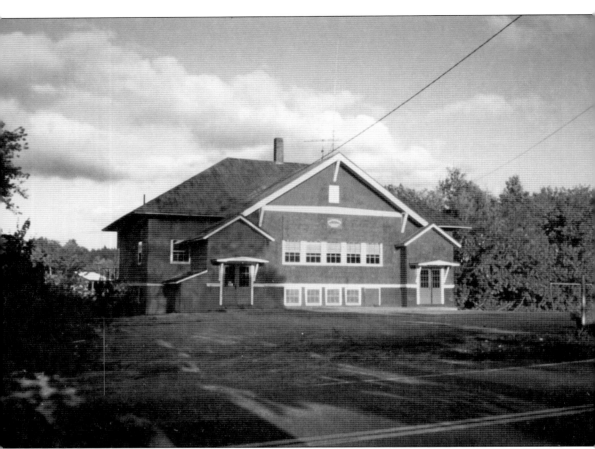

This photograph was taken on September 29, 1992, when the society took over the school to use as a museum and general headquarters. Renovations to the old schoolhouse took much time and many hands. The renovations were documented in photographs by Ester Holt. Her entire photo album collection is available at the Vassalboro Historical Society's library. A special thanks goes to the town and its many residents for their past, current, and continued support.

Two

South Vassalboro

George and Lillian Pierce are photographed here with their daughter Elona. Lillian is carrying her next child, daughter Nina, who grew up to become Vassalboro's town clerk. The building once housed the South Vassalboro Post Office on the lower level. It was the boyhood home of Judge William Penn Whitehouse.

Maple Leaf Market sat on the east side of Route 3/North Belfast Road in South Vassalboro. Ernest St. Amand and his niece Chantel owned and ran the store in the late 1950s. The store was in a good location for travelers coming from Augusta through the China Lake area to Belfast. The building still stands but is now a private residence.

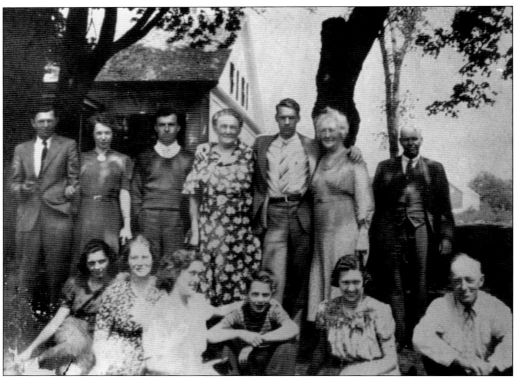

This photograph is of the Whitehouse family from South Vassalboro. From left to right are (first row) Glenda Proctor Whitehouse, two unidentified young women, an unidentified boy, an unidentified woman, and Daniel Whitehouse; (second row) an unidentified man, Florence Whitehouse Vaughn, Wilmer Abram Vaughn, Hallie Whitehouse Weeks, Raymond Waldo Whitehouse, Lillian Whitehouse Pierce, and an unidentified man.

Three
CENTER VASSALBORO

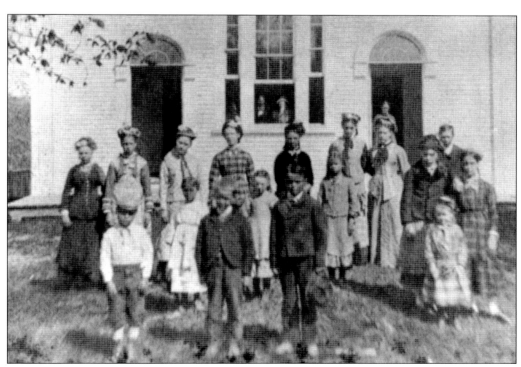

The Center Vassalboro Baptist Church Sunday School is pictured in 1890. The people in the photograph are, from left to right, (first row) Bertie Dunham, Willie Dunham, and Luther ?; (second row) Nettie ?, Fanny Estes, Annie Nelson, Ida Austin, Anna Brown, and Helen Austin; (third row) Mary Austin, Emmie French, Kate Rollins, Anna Grover, Abbie Stevens, Ella Colby, Ellen Graves, and Asa Nelson. The person in the doorway is unidentified.

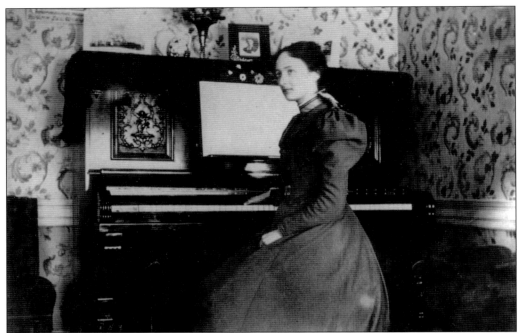

Olive Sarah Marden, later Pope, sits at her piano. She lived from 1879 to 1956. This photograph was taken when she was living at the brick house on Bog Road in Center Vassalboro. Diaries of hers, written after she had become Olive Pope, can be found at the Vassalboro Historical Society.

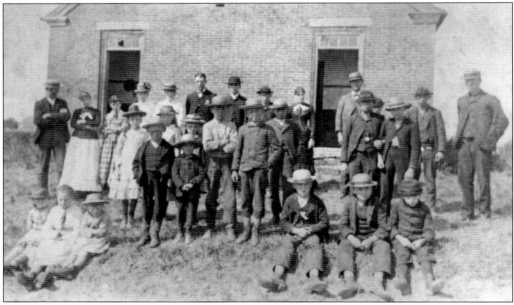

Cross Hill School was District No. 8 in Vassalboro and operated from 1876 to 1893. Voters at a meeting on April 28, 1976, wrote their "desire that when finished it [the schoolhouse] shall be kept free from mutilation." On June 17, 1876, the record says that "the schoolhouse is burnt." The schoolteacher was paid $3 per week in the summer and $5 per week in the winter, plus room and board.

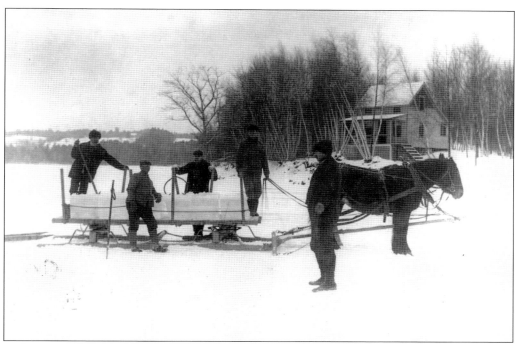

Ice harvesters collect ice blocks with a horse-drawn sleigh on Webber Pond. Many "cakes" of ice are already loaded onto the sleigh. Two horses wait patiently in the snow. The second man on the left is identified as Merton Rowe of Riverside. His son was Urban Rowe Sr., a town constable in 1971.

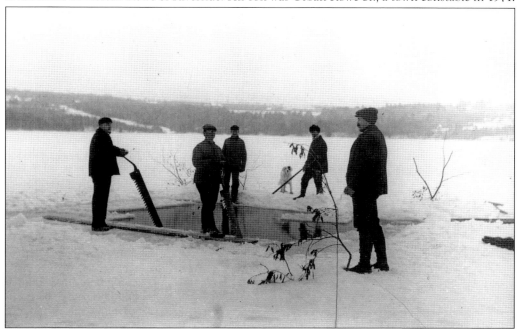

Ice harvesters cut ice blocks out on Webber Pond with long saws. A dog stands in the back, staring directly at the camera, with five men all bordering the open patch of water where the ice is being removed. The second man to the left is identified as Merton Rowe of Riverside.

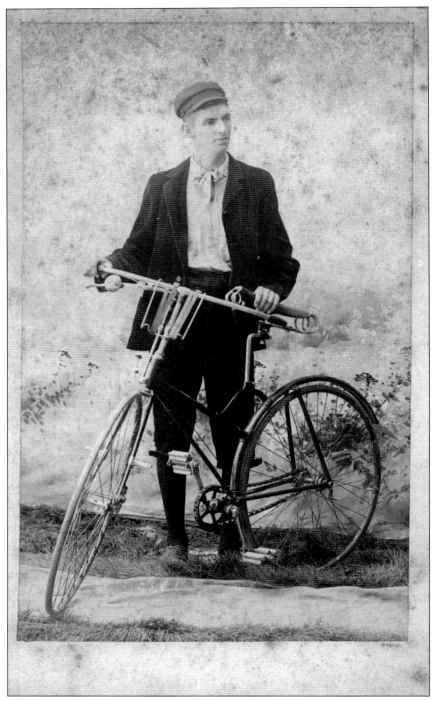

Samuel G. Burleigh, of Center Vassalboro, is shown with his bike. He was the editor of the *Clarion*, Vassalboro's town newspaper. The first volume was released in March 1886; the opening remarks state, "Our object is the dissemination of truth, and temperance, and the advancement of Scientific and practical knowledge among our fellow men."

The Steeves family is shown on the south side of their Cross Hill home in the 1950s. They are identified from left to right as follows: (seated in chairs) Clara Price Steeves and Edgar H. Steeves; (seated on the arms of the chairs) Pearl Steeves Frost and Gertrude Steeves Richards; (standing) Lena Steeves Cunningham, Evangeline Steeves Rowe, Elliot Steeves, Everett Steeves, Viola Steeves Knowles, Evelyn Steeves Goodmaster, Hubert R. Steeves, and Mary Steeves Smith.

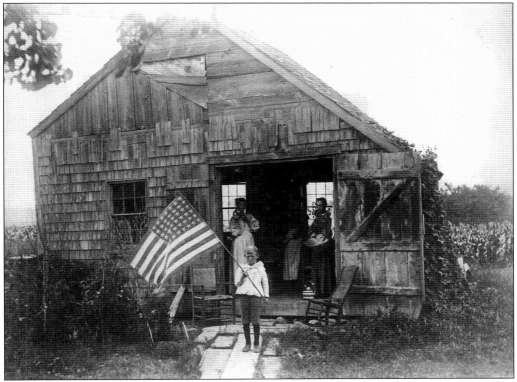

This summer kitchen belonged to Charles Barker and was located at the corner of Route 32 and Nelson Road. Summer kitchens were used during hot summers and fall canning seasons to keep living quarters cool and to provide storage of canners and other seasonal kitchen equipment. This home later belonged to Winston Bradley, a blacksmith. In the late 1970s and early 1980s, Bradley opened his barn (before the new hay went in) for barn dances. Charles Barker, who lived from 1889 to 1961, was married to Gertrude Barker (1882–1961). The Charles Barker homestead later became the home of Walter and Joyce Rowe.

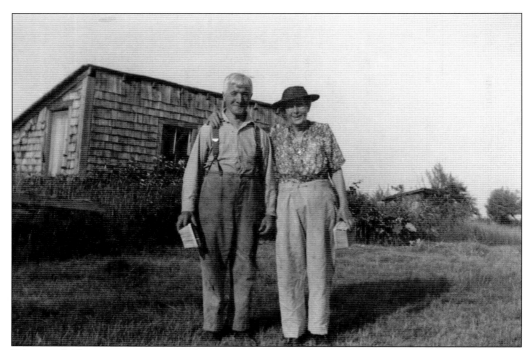

Edgar and Clara Price Steeves are shown together sometime in the 1930s. This photograph shows them on Cross Hill Road after they had come back from berry picking. A chicken house can be seen standing behind the happy couple. Edgar and Clara's descendant Russell Smith is a volunteer at the Vassalboro Public Library as well as the Vassalboro Historical Society.

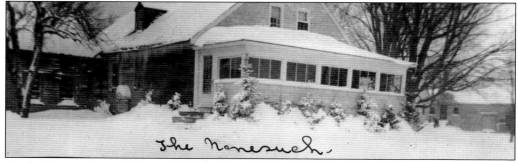

At the intersection of Hussey Hill Road and Taber Hill Road, this home was purchased in 1932 by Fred and Louise Oliver. Named the Nonesuch after Fred's beloved Nonesuch River in Scarborough, Maine, it was where Louise was raised. The home passed from the Olivers to their daughter, Carey, and her husband, Maurice Cain. The home has been remodeled, and the glassed-in porch has been removed. The Kennebec Land Trust Davidson Tract, donated by Elizabeth Davidson, was once a portion of the property.

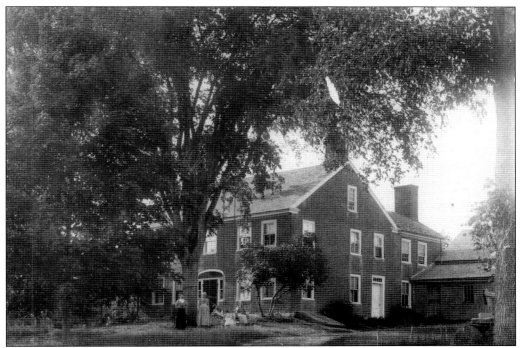

A brick house situated on Bog Road in Center Vassalboro was owned at the time by Sarah Taylor Marden. She is shown in the picture flanked by both of her daughters. The daughter on the left is Olive Marden, and on the right is Rosa Marden Tufts. The photograph also shows Tufts's daughters Irene and Sarah. Sarah Marden is buried in a cemetery behind the home.

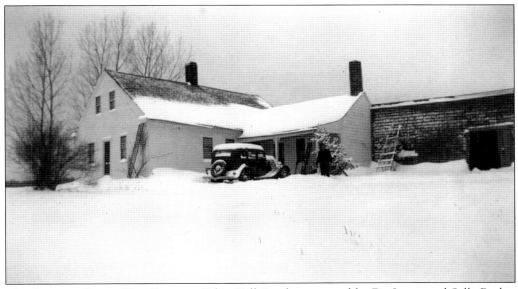

This home in Center Vassalboro on Taber Hill Road was owned by Dr. James and Sally Butler. Shown in the thick of winter, the dirt road beneath is not visible. James stands in the blanket of snow just to the right of the car. While the date of the picture is unknown, it can be assumed it was taken sometime in the 1930s.

The so-called Small Schoolhouse was located at the intersection of Bog Road and Webber Pond Road. It was named after the Small family, which at one time owned the nearby brick house. At the time this picture was taken, it had been discontinued as a school and was occupied as a dwelling. It was eventually abandoned and torn down by the town.

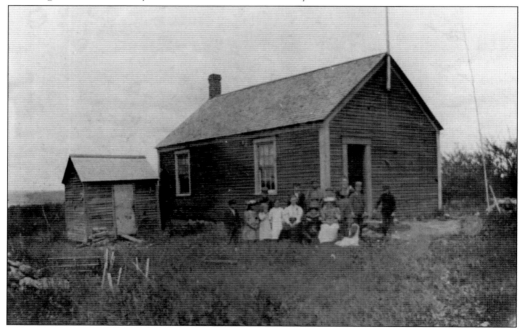

The Perley School in Center Vassalboro is shown in 1896 with Webber Pond in the background. Annabel Ingraham taught at this school beginning in 1908–1909, when she moved to Vassalboro to live with her uncle. She was certified to teach all grades, and as her class book (available at the Vassalboro Historical Society) shows, she taught many.

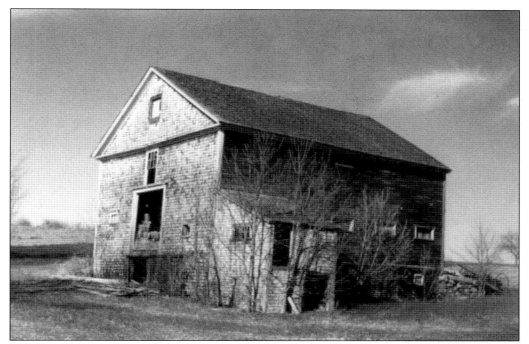

This barn was once the Congregational church on the River Road between Riverside and Getchell's Corner. It was built in 1816 where the Union Cemetery is. Rev. Thomas Adams was the pastor for many years. Attendance declined, and it was replaced by the current Riverside Church. Henry Sawtelle bought it and moved it south and across the road, converting it into a barn.

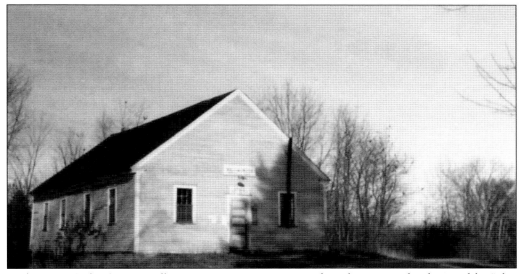

Built in 1795, the first Vassalboro Town House was moved to this site on land owned by John Dutton near the center of town around 1828. It was used until 1940, when the town offices moved to Citizen's Hall. It was vacant for years until the Center Vassalboro Men's Club began meeting there. During the 1960s and 1970s, the building came alive with dances, weddings, reunions, and meetings. The Kennebec Valley Trail Riders Snowmobile Club was the next owner. The building was burned by an arsonist in 1979.

Pictured is the former home of Tom and Mary Heeg in Center Vassalboro; they purchased the property in December 1969. Both Tom and his wife volunteered at the Vassalboro Historical Society. Mary Heeg was part of the US Army, and her donated uniform can now be viewed at the Vassalboro Historical Society.

This photograph of the Prescott house was most likely taken sometime around 1913. This house was built by Dr. Oliver Prescott of Winthrop, Maine, whose wife was Lydia Chandler, also of Winthrop. He received a degree in medicine at Dartmouth College and then settled in Vassalboro. He practiced till his death in 1853 at the age of 62. He also served two years in the Maine Senate.

Before the days of "Old Age Assistance," indigent and needy people who had no family or means of support were sent to the Vassalboro Town Farm. Those who were able helped with chores and the gardens. This place is on the Webber Pond Road, north of Natanis Golf Course, on a section of the road that had been cut off with the straightening of the Webber Pond Road.

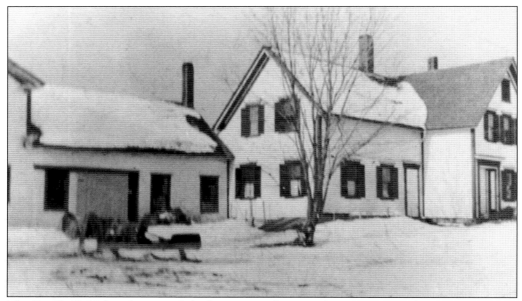

The Orville D. Nelson house and shed were on Nelson Road in Center Vassalboro. It once stood where the Harold Nelson place used to be. The house in this photograph burned in August 1937 because the barn, which was connected to it, was struck by lightning. When the fire department came to fight the fire, it had a new pumper; firefighters hooked up the hose wrong and could not get things in proper order to fight the fire.

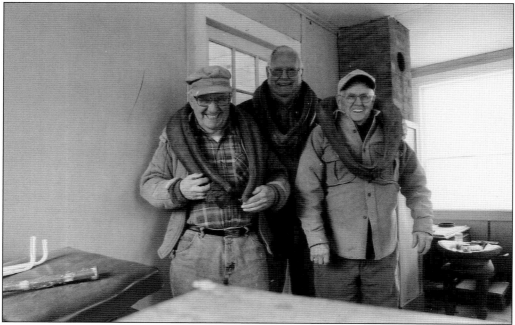

The "Three Amigos" were the work crew for many years. They were comprised of, from left to right, Paul Duplessie, building director David Bolduc, and Roy Brackett. These loyal volunteers handled everything from building shelves to painting, cleaning, shoveling, hanging pictures, and any other task that showed up on the curator's "Honey Do List."

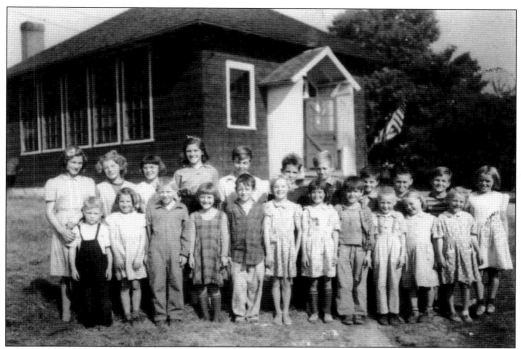

Students at the Cross Hill School included, from left to right, (first row) Thurlow Bickford, Genevieve Dyer, Howard Cunningham, Carmen Derosier, David Dyer, Marlene Rowe, Jane Derosier, Kenneth Dyer, Bryan O'Hern, Brenda Cunningham, and Shirley Cunningham; (second row) Jessie Bragg, Noreen Cunningham, Clara Cunningham, Muriel Bragg, Robert Rowe, Herman Dyer, Clyde Bragg, Steven Steeves, Roger Glidden, Edison Bragg, and Donna Cunningham.

The Center Vassalboro Community Baptist Church was dedicated on October 22, 1840. The First and Second Baptist Churches of Vassalboro held a meeting on October 12, 1839, where they decided to merge the churches into a single unit. It was used for some time until it was abandoned. Although it was left to the elements for a time, the building was restored in October 1940 with a three-day dedication. It is now the office of the American Baptist Society.

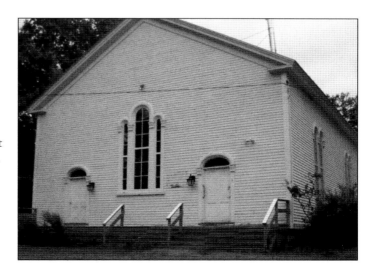

The Jones Homestead on Quaker Lane in Center Vassalboro is now the location and home of Fieldstone Gardens and the Jones family. Maetta Jones and her son Steven still live on the property. This photograph was taken in 2001. The stone wall has been a part of the property since Ezra Jones owned it in 1965.

The Vassalboro Community School, which sits on the corner of the Webber Pond Road and the Bog Road, was built in the early 1990s and was finally opened in 1992. This school was built to consolidate all the schools in the town of Vassalboro. The playground was added after 2000.

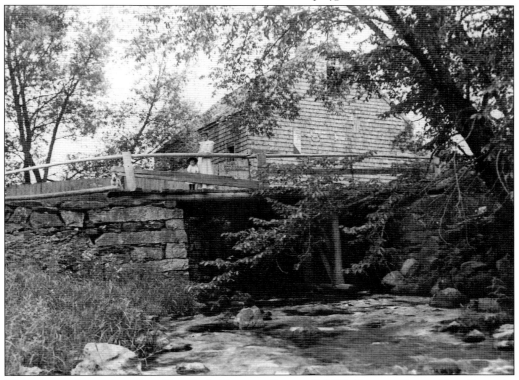

This picture shows the gristmill at the bridge over Seaward's Mills Stream, Center Vassalboro, in 1900. On Seaward's Mills Stream in the early 1900s, one could also find an excelsior mill, which produced fine wood shavings, and a sawmill.

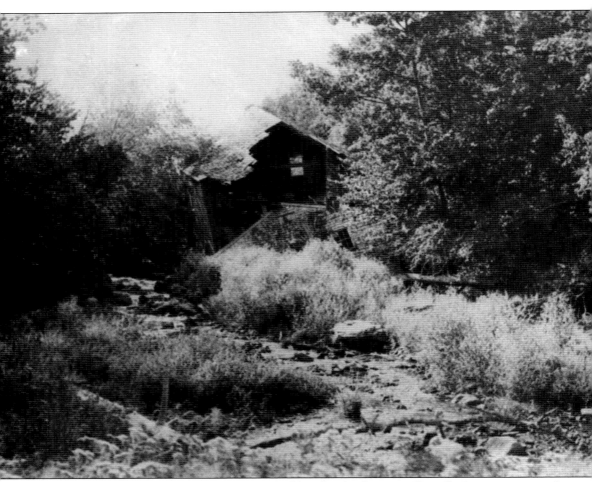

The excelsior mill, shown here, now stands dilapidated. The Seward's Mills Stream connected Three-Mile Pond with Webber Pond and furnished the water used for power for Seward's Mills. In addition to the mills shown, there was also a store, mechanic's shop, post office, and blacksmith shop.

Four

East Vassalboro

This photograph was taken on August 17, 2000, and shows one of the two gingko trees that were planted by Steven Jones of Fieldstone Gardens around 1998. The second tree was later replaced. The flowerbed is in front of the Vassalboro Historical Society Museum. Behind it is Route 32, with the Country Store shown in the background.

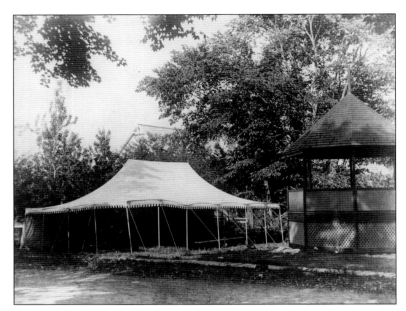

The East Vassalboro Bandstand's original location was where the Grange Hall is now. The wooden sidewalk shows along the side of the road. The background has the peak of Ina Hussey Weymouth's barn, now belonging to the Vassalboro Historical Society.

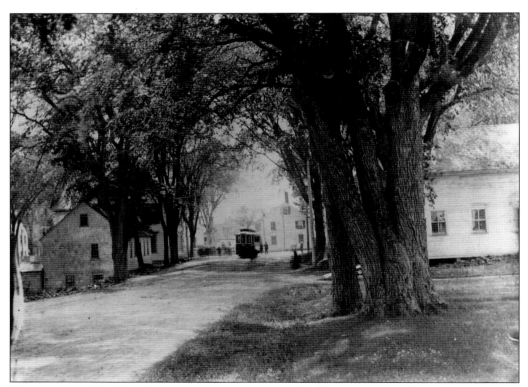

This picture of East Vassalboro shows Main Street and looks south toward the four corners. The large white building in the center was the old Revere House, now gone. The building at the right was a carriage shop and was the original East Vassalboro Methodist Church. Note the trolley with the crowd of people waiting on the left.

The Small house is located on Outlet Stream in East Vassalboro in front of the house once owned by George, Margaret, and Effie Cates. The foundation can still be seen. In 1856, it was identified as the J. Furbish place; in 1879, it was owned by the Vassalboro Mills (the name for the woolen mills at North Vassalboro).

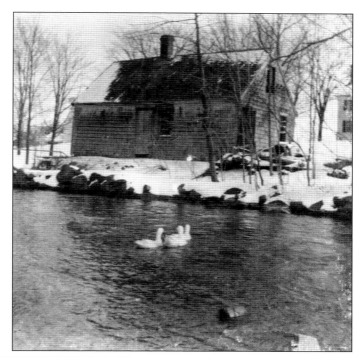

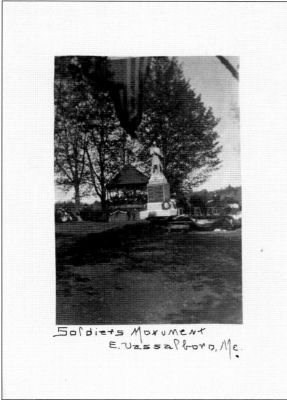

The Soldier's Monument in Monument Park, East Vassalboro, was set up in memory of Vassalboro men who fought and died in the Civil War. There are 56 names found on the monument. One of the names, James W. White, was identified and found to have lived until 1919. He and six other men listed on the monument were buried in the Methodist Cemetery in East Vassalboro.

The East Vassalboro Methodist Church can be seen in the background with Cates Country Store at the corner. The first Methodist church building was erected in about 1850. This one was built in 1871 and was in use until 1986, when it was voted to unite with the North Vassalboro Methodist Church. A new building was constructed on Route 32 about equidistant between North and East Vassalboro. The former churches were both sold. The Methodist church is still active in its new building.

The Vassalboro Friends Meeting House in East Vassalboro has been in existence since 1785–1786. The first worship meeting in Vassalboro was held in 1780 by David Sands. He wrote about the meeting house being built upon his return to Vassalboro years later. The first two or three winters, during which the building was still being finished, three-hour services were held even when there was no heat.

A postcard photograph shows Main Street in East Vassalboro looking north. The woman and man are Nancy Cates Barker and Levi Barker. In the rear of the Butterfield's Store was an ice refrigerator. Also note the building (now gone) that was first used as a Methodist church and later a carriage shop. Levi Barker kept carriages here, which he had for sale.

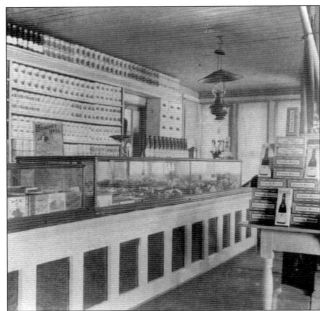

This photograph is believed to have been taken in the interior of Cates Country Store in East Vassalboro. Cates Country Store was run by the Cates family for many years. While the Cates family were popular for their store, they were also prominent in the town's Quaker community, as well as a few generations of town doctors.

George Cates's barn held his milking cows, and he sold the milk straight from the building. His cows were pastured across the road, and twice a day, traffic would be held up so they could cross. Many remember getting fresh milk from the shiny silver tank in the little building on the right.

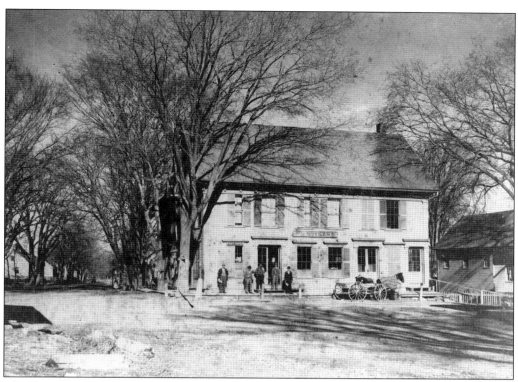

The Butterfield's Store was owned by George Cates, and it also housed the East Vassalboro Post Office. The building was located on the now vacant corner in East Vassalboro across from the Country Store and the Revere House. Before it was owned by the Cates family, it was owned by Jacob Butterfield in the early 1830s.

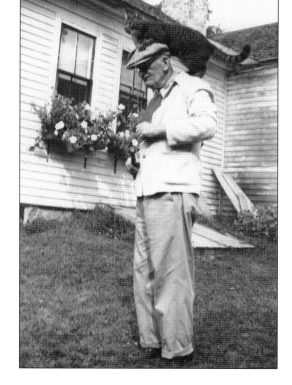

This humorous photograph of a man and his mischievous cat is of Harry Webber. Harry was born in 1876 and died in 1952. He was buried in the North Vassalboro Village Cemetery. The house behind him is his residence, located across the road from Freddie's Garage in East Vassalboro.

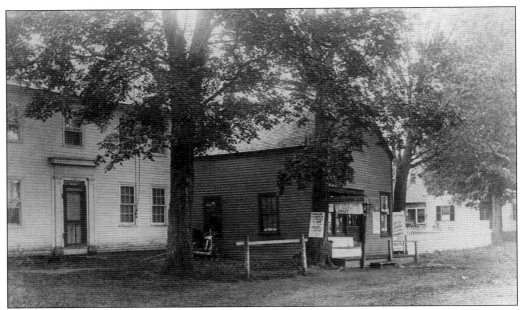

The F.A. Marden Store was located on Bog Road in East Vassalboro. The store and a house were owned by Frank Marden. The house was a Sears kit home and is still standing as a private residence. They were located across from the old Methodist church. The white house to the right of the property was Frank's house at the time but has since been replaced by a home that was owned by Ernest and Patricia Gauer in 2009.

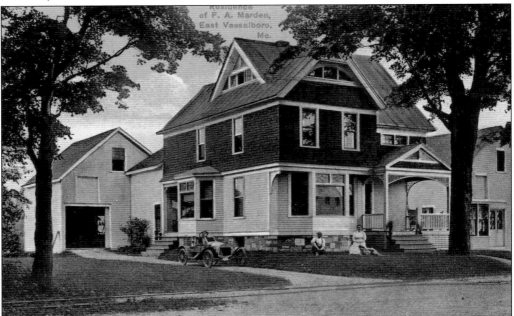

The house pictured here was built by Frank Marden, owner of the F.A. Marden Store. This home still stands in East Vassalboro to this day. It is the current residence of Laura Jones. She is a volunteer at the Vassalboro Historical Society who manages its social media and serves as the society's treasurer.

The East Vassalboro Post Office was built by Herman Masse sometime around 1951. Although the hours have decreased, the post office is still in operation. The building also contains four apartments. The US Postal Service, in 1996, decided on a merger of all Vassalboro post offices, and the town took a legal battle to save the East Vassalboro Post Office. It recruited the help of Sen. Susan Collins and Maine House of Representatives majority leader (in 1996) Elizabeth Mitchell in the efforts, and the post office was saved.

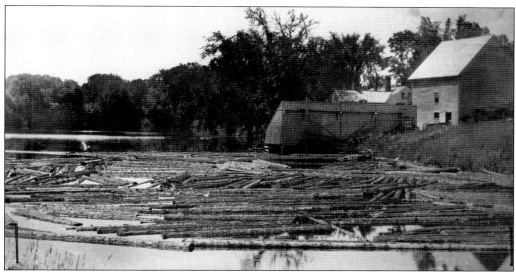

Purchased by Louis Z. Masse in 1912, the sawmill remained in the family until its closure in 1971. Records indicate that the original owner was the Vassalboro Mills Company. The property included a gristmill as well as a sawmill. Pine logs were stored during summer months in the mill pond to protect them from worms and to water-cure the wood. Masse's son Herman took over the mill in 1926, followed by his grandson Kenneth in 1969.

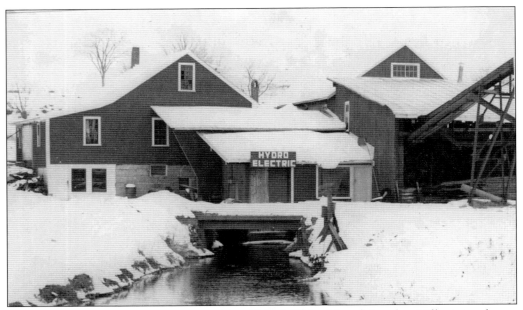

Masse's Lumber Mill, pictured with the bridge over Outlet Stream, was started by Herman Masse and eventually owned by his son, Kenneth Masse. By 1972, the entire mill had run off water power before being converted to diesel fuel. The mill was known for its specialty cuts that were not widely found in common lumber mills. With the rise of custom-built homes, this was a focal selling point for their lumber.

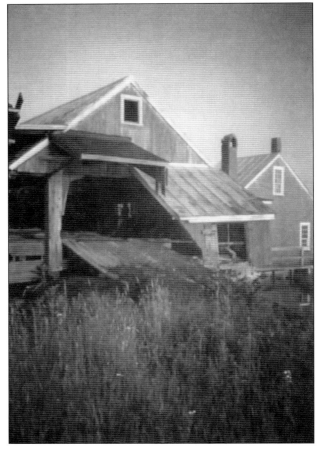

Masse's Saw and Grist Mill are seen in this view looking northwest. Notice the "ship's knee" brace on the upright post. The photograph was taken by Steven Robbins. A ship's knee was a natural or cut curved piece of wood. They were a common form of bracing in boat building and occasionally timber framing.

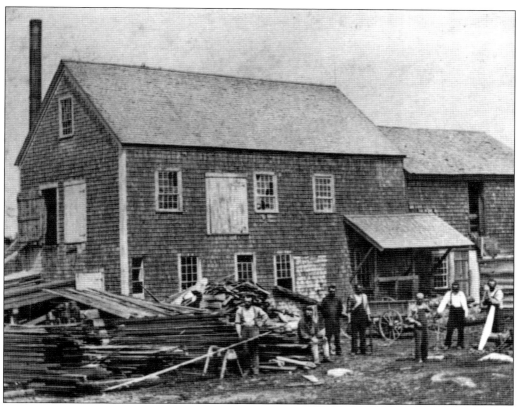

The current East Vassalboro boat landing was once home to the Butterfield Bros. Shingle and Shovel Handle Mill. In the late 1800s, the brothers advertised themselves as "Dealers of Sawed Wood of Any Dimensions" and sold lumber to order, including sawing and planing. Brother Andrew Butterfield (1824–1894) is buried in the East Vassalboro Methodist Cemetery, while brother Jeremiah (1824–1913) is buried in the North Vassalboro Village Cemetery.

The Vassalboro Public Library was originally a cottage on the shore of China Lake and was given to the Library Association by the Kennebec Water District about 1914. The building was towed by several teams of horses across China Lake. This photograph was taken across from its new location on South Stanley Hill Road on land donated by the Cates family.

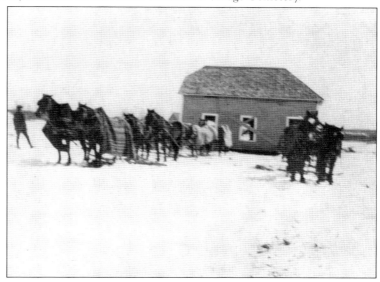

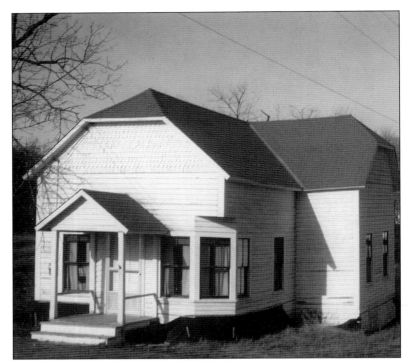

The Vassalboro Public Library is shown at its new location and with a fresh new look. This building was donated by the Kennebec Water District, and the land it was located on was donated by George Cates. At its start, the library offered its services to Vassalboro, Winslow, and China residents. The library burned in 1979.

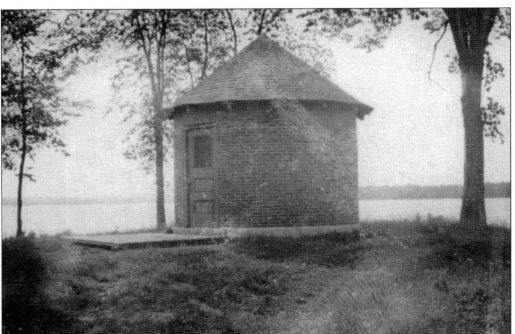

This was the Kennebec Water District Pumphouse before the new building, still here today, was built in 1993. While the pumphouse still uses water from China Lake, there is nothing else similar about these buildings. The building today now boasts three filtration tanks with a capacity of four million gallons a piece.

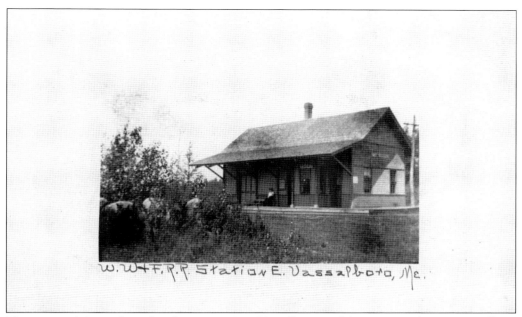

This postcard shows the railroad station in East Vassalboro used for a time as the East Vassalboro Post Office under Postmaster Harry Jones. There were a handful of railroad stations scattered through the corners of Vassalboro, and this was only one station along the route. The convenience of having stations at all ends of Vassalboro cannot be overstated.

The Tingley's Shingle Mill on Outlet Stream in East Vassalboro was owned and operated by George Agreen Tingley. Born in Canada, he settled in Vassalboro after marrying Anna Mariel Morneau. He died on March 4, 2005. The mill itself was about 80 feet by 200 feet and consisted of 108 looms.

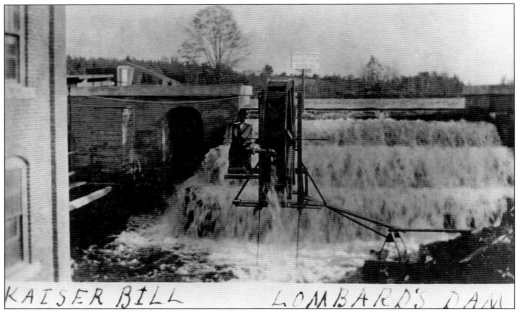

Kaiser Bill cranked the waterwheel at Lombard's Dam in World War I. The dam was removed sometime in the 2020s. A.O. Lombard used his mill to make a political statement about the last German emperor and king of Prussia, who ruled from June 15, 1888, until his abdication on November 9, 1918. Lombard put him to work on the water wheel.

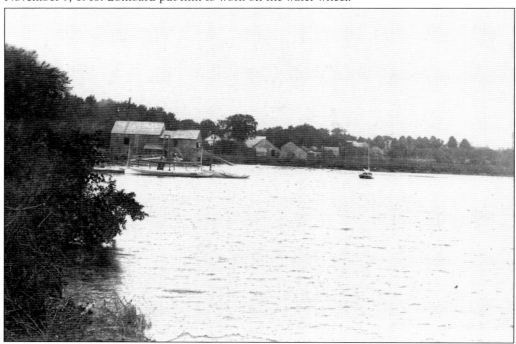

Butterfield Steam Sawmill was located on the site of the present boat landing on China Lake in East Vassalboro. It was run by Andrew and Jeremiah "Jed" Butterfield. The farm in the background would be the Cates property. Note the steamboat tied up at the wharf.

Piper's Mill on Outlet Stream in East Vassalboro was passed within the Piper family from generation to generation. Florence Piper was deeded the property while she was an infant. In 1933, according to the Kennebec County Registry of Deeds, Florence Piper deeded the property to Leo Morneau, "including water privilege and power appurtenant to said shingle mill and old grist mill."

Pictured here is a cottage on China Lake in East Vassalboro. Back in the 1920s, there were around 20 cottages and campgrounds around this area. During this time, the Kennebec Water District tried to buy up all the properties. Everyone sold their vacation spots except for the Shoreys. To this day, the Shoreys maintain ownership of their family cottage.

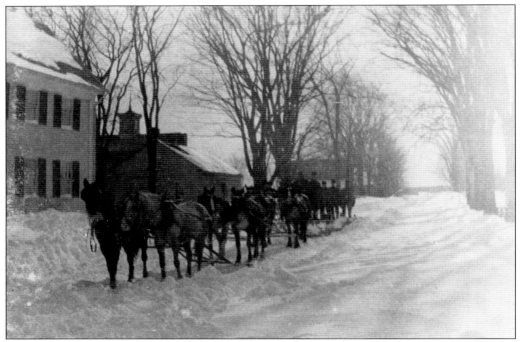

This photograph shows Main Street in East Vassalboro covered in freshly fallen snow. Six horses are shown pulling a plow with men on it to clear the street. It is assumed that this was after the snowstorm in February 1899. The steeple of the East Vassalboro Methodist Church is visible in the background to the left.

This photograph showing the dam house at East Vassalboro was dated August 1956. It was taken from the upper floors of the Revere House. Showing to the far right is the home of Paul and Elizabeth Cates. The corner of the East Vassalboro Grammar School can just be seen on the right of the photograph.

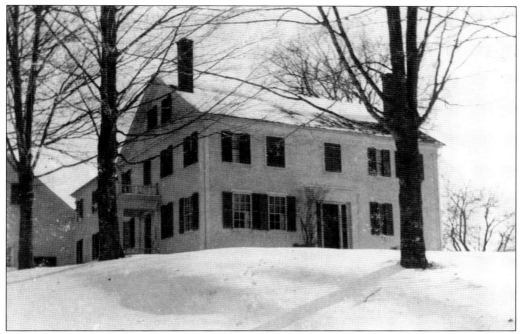

The Cates family home is located on South Stanley Hill Road. Benjamin H. Cates Sr. and Annabelle Ingraham Cates had 11 children. This building is currently the home of Cates Gladiola Farm. The Cates family homestead was built in 1858 by Dr. Samuel Cates's grandfather. His father was David B. Cates.

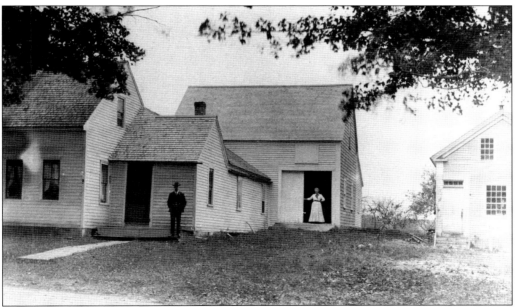

Margaret Annette Lampson Davis's home sat directly across from the East Vassalboro Grange. Her parents were Walter Howard Lampson (1872–1955) and Margaret Tait Lampson (1882–1956). Annette, as she was called, served as a technical sergeant in the Marines. The building on the right was a harness shop and was relocated to the Vassalboro Historical Society property next door.

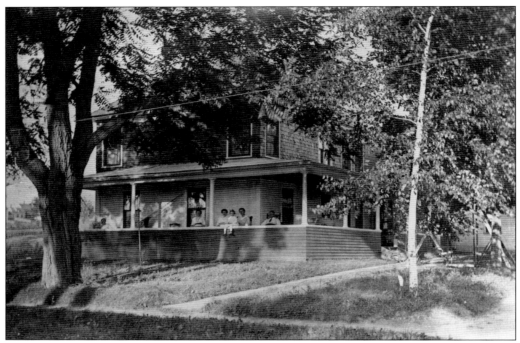

This was the home of Frank Hussey, a funeral director in East Vassalboro. His daughter Ina Hussey Weymouth followed Frank in the business and converted a portion of the house into a funeral parlor. Between father and daughter, the Hussey Funeral Home was in operation from 1906 to 1959. This photograph shows a group enjoying time together on the front porch of the gracious home.

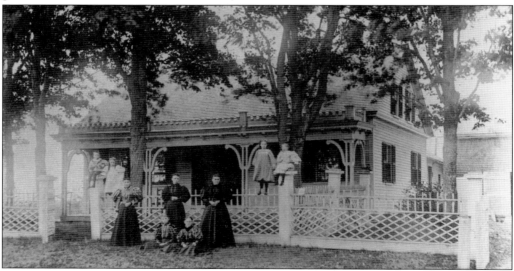

This lovely home, located next to the Vassalboro Public Library, was owned by the late Gertrude "Trudy" Overlock, who kept the rooms in museum quality. It was built in about 1805 by Phillip Leach. The Greek Revival Cape has Moses Eaton stencils on the walls of the westerly room, believed to be done about 1824. The cellar has granite walls and brickwork. The front porch was removed in 1953, and the barn burned about 1960.

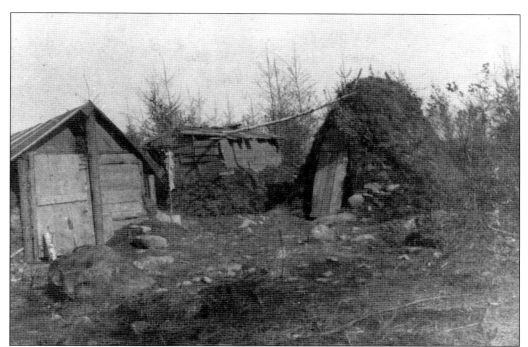

These round huts housed foreign laborers brought in to construct the trolley line. The trolley ran from Lewiston to Augusta, Waterville, and Vassalboro and made stops in North Vassalboro, East Vassalboro, and Webber Pond. The trollies did not make it past the 1930s, however, as private automobiles became more common and convenient.

The East Vassalboro Grange stands next to Ina Hussey Weymouth's barn. The Grange was organized on March 27, 1895. The Vassalboro Grange Corporation was organized later, in 1899. The yellow building still stands and is still used as a community hot spot to this day. Numerous plays, dances, fundraisers, and the like have been held (and continue to be held) at this beacon of the township.

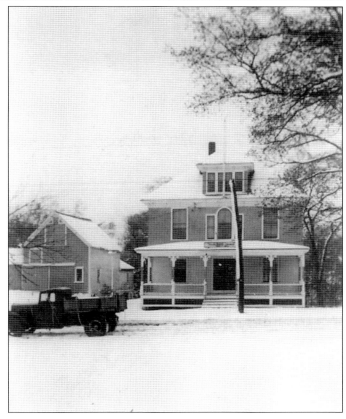

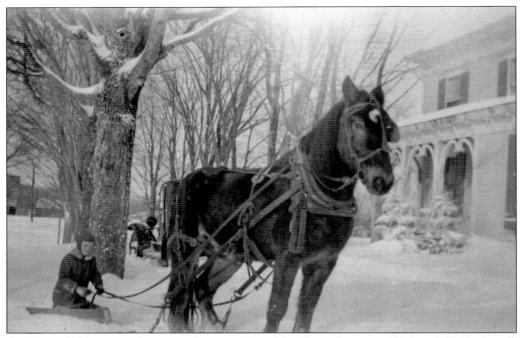

Dr. Samuel Cates was the town doctor in East Vassalboro between 1926 and 1951. A well-respected and well-loved doctor, Cates made house calls during his time of employment. It is notable that his grandfather was also a doctor, and his father was a farmer. Dr. Cates was also an accomplished farmer.

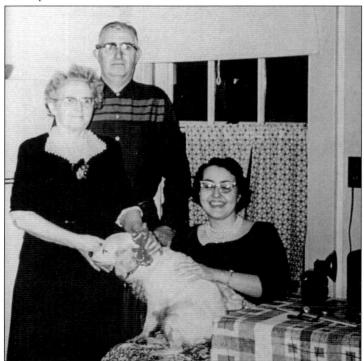

During the Christmas holiday in 1958, Elizabeth "Betty" Taylor came home from California to spend Christmas with her parents. This photograph was taken in the kitchen of her parents' home in East Vassalboro with her mother, Eula "Phil" (Philbrick) Taylor; her father, Harold Cooper Taylor; Elizabeth, and dog Candy.

This beautiful Greek Revival house was built in the 1840s. The front rooms on each side of the front door each have 12 sides. There is a unique curved stairway in the central hallway. The front porch features a fanlight, sidelights, and pillars. This is one of only two houses in Maine with this feature. The man standing near the house is Francis W. Coombs, believed to be a former owner of the property.

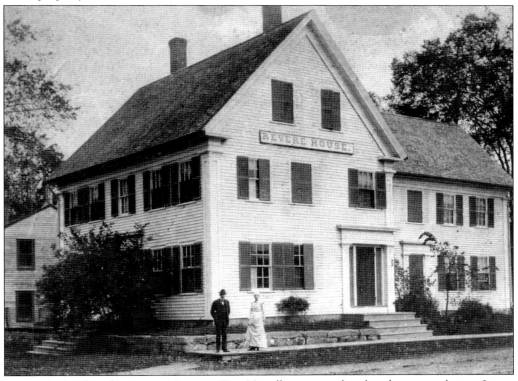

During its heyday, the Revere House in East Vassalboro was a hotel and stagecoach inn. It was owned by Albert Bradley and his sons. At one point, the owners sent wagons into Waterville on Sundays to pick people up for a ride on China Lake on one of the steamers that they owned and then return for supper at the Revere House.

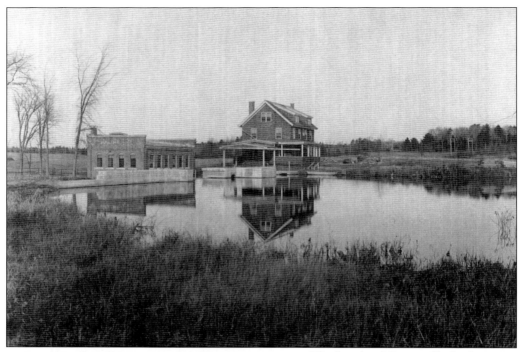

The Lombard Dam mill wheels once turned electric generators to produce small amounts of hydropower for the Rodericks, Masses, and others. Originally known as the David Dam, this area was purchased by Alvin Orlando Lombard, and the name was changed. Lombard, born in 1856, was one of 10 children who all became inventors in their later years. Lombard, after his retirement, invented the tractor head for the Lombard Log Hauler.

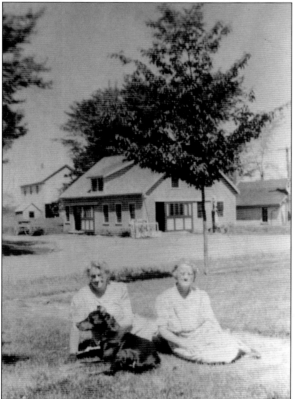

Jane "Jennie" M. Fletcher Hussey (1882–1967) of East Vassalboro is shown on the left, and her sister Blanche Fletcher Cole of China and East Vassalboro is shown on the right; the dog's name is Duke. Jane Hussey was the wife of Alton F. Hussey (1883–1966) of East Vassalboro, who ran a funeral home there. The sisters are sitting on the Hussey lawn.

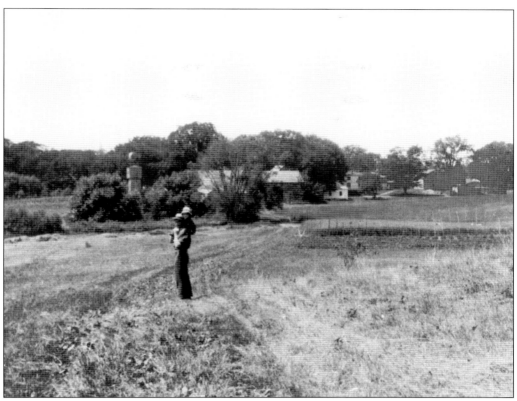

This photograph shows the Harold Cates farm about 1923. Harold and an unidentified child are in the field. The windmill visible in the distance was originally built to draw water from the brook into a tank to irrigate the upper field of the farm. Later, a motor was installed to provide irrigation for the lower section.

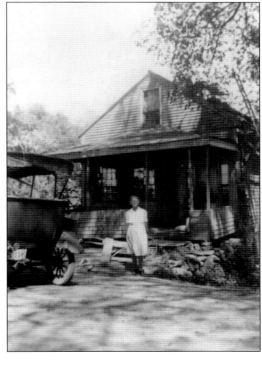

Lovina Trask is pictured standing in front of her house at East Vassalboro, a home that was later owned by Daveeda Brown. After her purchase of the property, it was then given to Daveeda's daughter Susan Little in 2015. Lovina Trask was a sister of Mrs. Austin of Cross Hill Road.

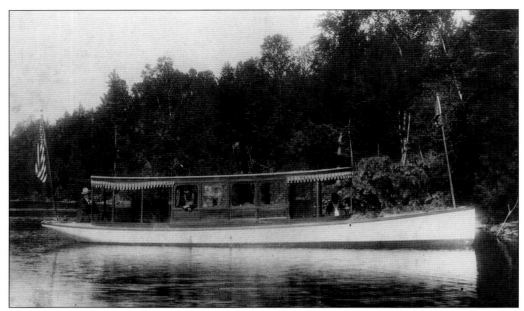

The master and owner of the steamer *Una* was William S. Bradley. The certificate of inspection was dated August 13, 1901, and the *Una* was approved to carry no more than 30 persons on China Lake. The *Una* was built in Bath with a hull constructed of wood and a steel boiler. Safety measures included one ax, two buckets, oars, 10 life preservers, and cork-filled cushions and floats, as well as a steam whistle.

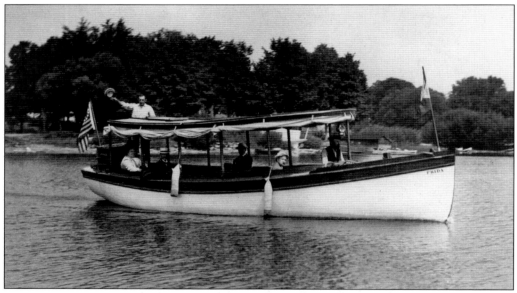

In the late 1800s and early 1900s, steamboats were very popular on China Lake. The *Comet* and *Frida* were only two of the steamers that traveled on China Lake. The steamer *Una* was used to take guests to Bradley's Island. The island had a 100-seat dining room, a bowling alley, and a dance hall. Guests of the Revere House were provided transportation to the island on the *Una* or the *Lizzie*. Most steamboats could travel as fast as five miles per hour, which made the approximate mile-and-a-half trip to Bradley's Island a breeze.

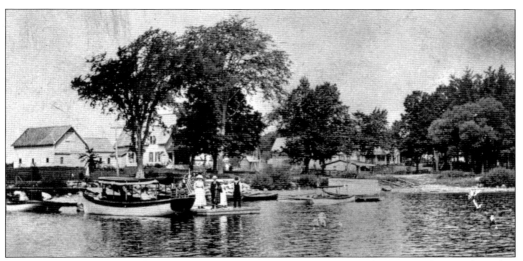

In the late 1800s and early 1900s, several boats were in recreational use on China Lake. This photograph shows a scene at the wharf on Route 32 in East Vassalboro. Note the flag, the beach for swimmers, and the boathouse on the right. The structure in the center is probably a windmill. The LaChance home is on the left.

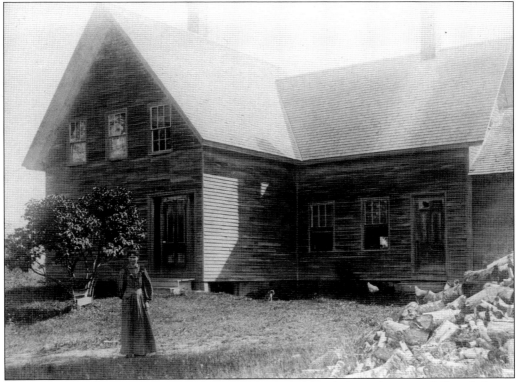

This photograph shows the home of Edward Stone Bragg with his wife, Cora Philbrook Bragg, standing out front. This property is located on Route 32 in East Vassalboro. Edward (1852–1926) and Cora (1855–1942) were both buried in the East Vassalboro Methodist Cemetery. This property was later the site of Carroll Rowe's barn in 2010.

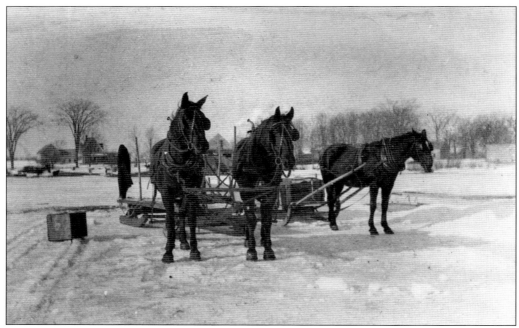

The photograph below of China Lake in the winter shows a scow, two pairs of horses, and seven unidentified men standing on the scow. The George Cates property is in the background. Visible in the distance is a windmill. Before the age of refrigerators, ice cutting and harvesting was a necessary and lucrative business. Blocks of ice were stored in icehouses using sawdust as insulation to keep the ice as long as possible. Electric refrigeration slowed and eventually stopped ice harvesting in most places in the 1940s. Vassalboro's Webber Pond and China Lake were the primary sources of ice during the winter, although smaller harvesting may have been done on the other ponds.

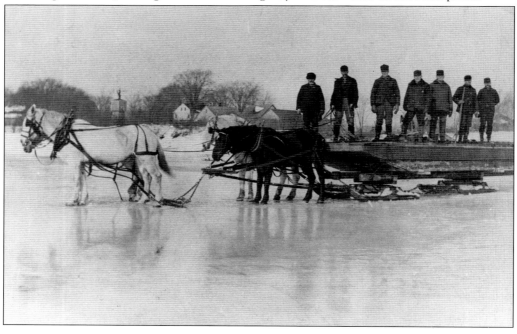

Margaret Annette Lampson, born January 14, 1915, is shown with her dog Teddy. Margaret Lampson (later Davis) passed away in 2006. This photograph was taken by her father, Walter Howard Lampson, when she was either four or five years old. Walter was born in 1872 and passed away in 1955.

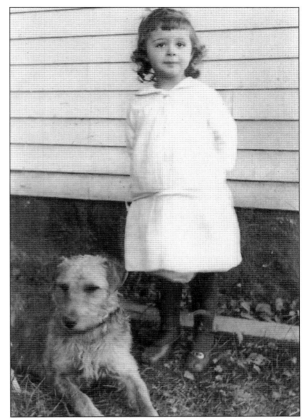

Leo Morneau is pictured at his mill in East Vassalboro, Morneau's Lumber Mill, which was located across from the Kennebec Water District Plant on Route 32. His hydroelectric facility ran a hydro generator that produced much of the power for home heating in the winter and pumps for his trout pond in the summer.

Herman Masse is pictured showing some of the equipment at his East Vassalboro Lumber Mill. Herman bought the mill from his father, Louis Masse, in 1929. He worked in the business alongside his father and son, Kenneth Masse, for 43 years. He retired in 1970 and passed away in 1990.

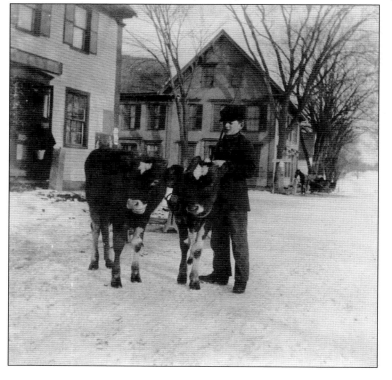

William Karl Cates (1885–1951) always went by Karl. This photograph was taken at the four corners in East Vassalboro. To the left is the Country Store (since in and out of business). It was most likely the Cates Store when this photograph was taken. In the background is the old Butterfield's Store (also run by the Cates family at the time).

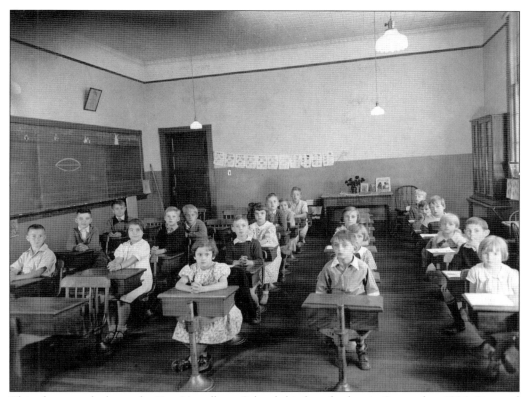

This photograph shows the East Vassalboro School third-grade class in September 1936. Pictured from left to right are (first row) Charles Hamlin, Floyd Jordan, and Leland Giroux; (second row) Alice Goodale, Lawrence Bartlett (age 8 years, 6 months), and Albert Hagerup; (third row) June Cates, Barkley Taylor, Joyce Haslem, Roy Dowe, Pearle Rude, and Hernan Rude; (fourth row) Charlie Low, Pauline Vigue, and Carmount Jacques; (fifth row) Hattie Rude, Kenneth Tuck, Patricia Vigue, Paul Page, Archie Goodale, and unidentified. This photograph was taken in what is now the Vassalboro Historical Society Museum.

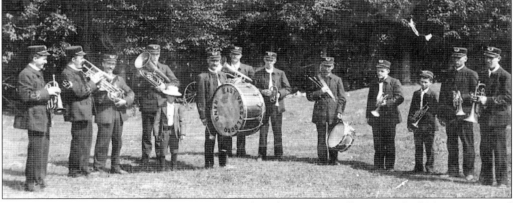

The *Waterville Mail* reported on May 26, 1897, that the East Vassalboro Band of 15 pieces arrived and escorted players to the baseball field, where large numbers had gathered to witness the game. On September 22, 1897, the band would furnish music at the Windsor Fair. The names of these band members can be found at the Vassalboro Historical Society.

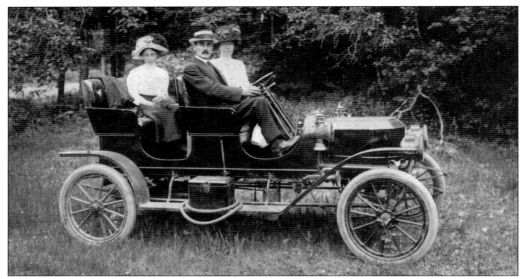

Harry Kinsley Butterfield (1868–1952) of East Vassalboro is shown driving his Stanley Steamer automobile. The women riding with him are identified as Claire Henry and Miss Cook. The picture was taken in July 1912 in Providence, Rhode Island, right before they headed home to East Vassalboro.

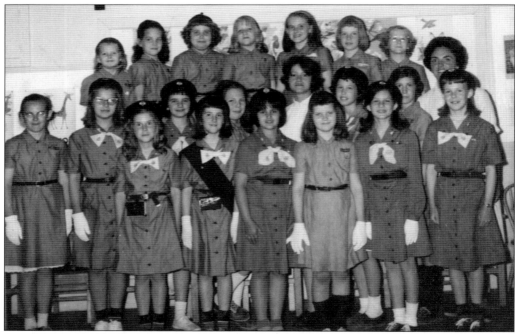

A Girl Scout troop in East Vassalboro is seen here in about 1965; from left to right are (first row) Marilyn Cain, Diane Mitchell, Laura Lee Cates, Ann Gray, Kathleen Porter, Sharon Mitchell, Cynthia Lalime, and Cheryl Nelson; (second row) Andrea Lalime, Sharon Hopkins, Vicki Stearns, Catherine Davidson, and Dawn Bouchard; (third row) Patricia Otis, LouAnne Hopkins, Ruth Ellen Lancaster, Susan Breault, Janice Cain, Judith Wentworth, Deborah Robbins, and leader Freda Joy Masse.

Margaret "Peggy" Cates Carleton is shown looking lovingly at a painting of her father, Dr. Samuel Clark Cates (1890–1963). Dr. Cates married Mae "Jimmy" James in October 1923. They had two sons and one daughter: David Cates, Howard Cates, and Peggy Cates. Dr. Cates once said, "Yes, the hours are long and the trips lengthy, but it is a pleasure to meet the folks and be able to help them."

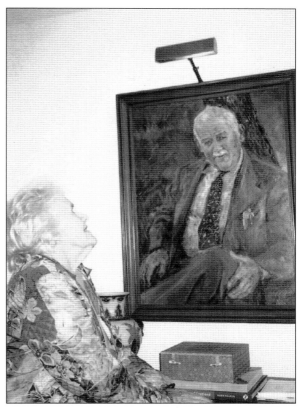

Warren Seaward (left) and Fred Whitney are photographed at Seaward's Mill, East Vassalboro (later Masse Lumber Company). Warren Seaward lived in the red house in East Vassalboro, near the mill, later owned by Frederick Pullen, and Fred Whitney lived in the yellow house on Route 32 in East Vassalboro now owned by the Antworth family.

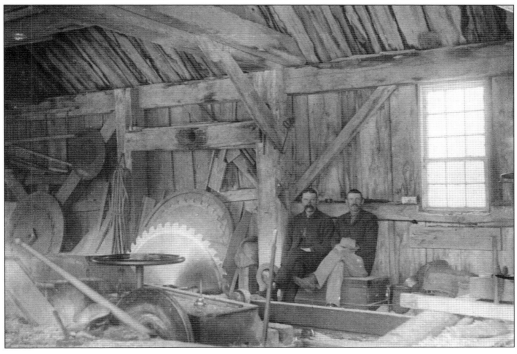

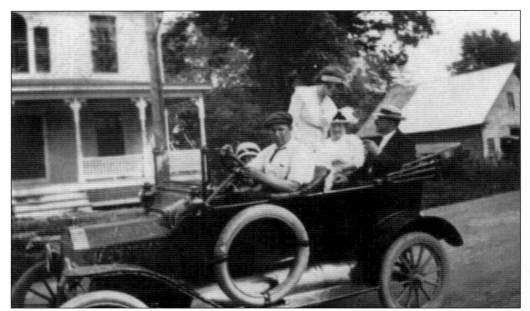

Taken sometime between 1915 and 1916, this photograph shows members of the Hussey family riding in a convertible with Henry Butterfield in the back. The car was most likely purchased at the Daniel Phillips dealership in North Vassalboro. The old Grange Stable can be seen on the right-hand side of the picture.

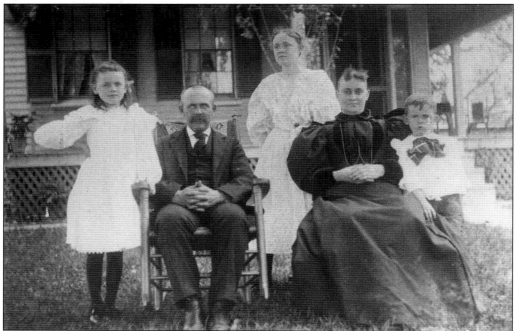

This photograph shows the Fred Z. Butterfield family of East Vassalboro. Seated are Fred (1869–1957) and his wife, Florence E. Bragg Butterfield (1863–1952). The girl in the middle is undoubtedly their daughter Zilpharetta. They are seated in front of their house across from China Lake, later to be the property of the LaChance family.

Elizabeth "Betty" Taylor was a prominent member of the town of Vassalboro her whole life. She was born here in 1931 and remained until her death in 2010. Her father, Harold Taylor, owned a blacksmith shop in town, and her mother, Eula Taylor, was a librarian and teacher. Elizabeth herself was a legal secretary and the town librarian, and she eventually became the historical society's curator.

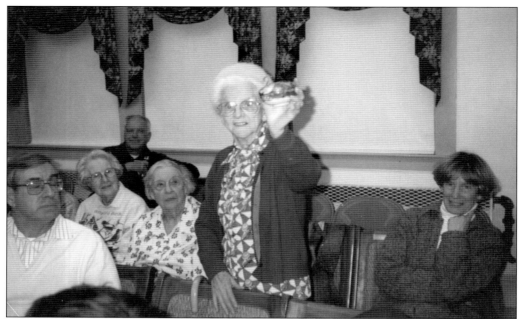

On February 20, 1997, the Vassalboro Historical Society held its annual Show & Tell. Pictured from left to right are (first row) Edward Wells; (second row) Viola Knowles, Annette Davis, Mildred Harris, and Julie Brown; (third row) Charles Ferguson. Harris was Vassalboro's librarian at the public library for a time, and Davis donated her estate to the Vassalboro Historical Society.

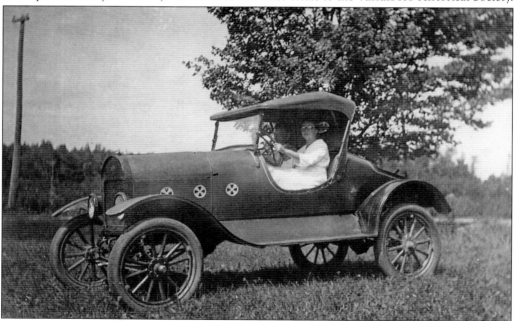

Gladys and Clarence Jones are pictured in "Rummy" (the car's nickname). Clarence bought this car from the Maine State Police. It had been used for running rum back and forth to Canada and was later confiscated and sold. This was a posed picture, as Gladys never actually drove the car. Gladys remarked once that they seldom used the car because Clarence often had it apart in the driveway.

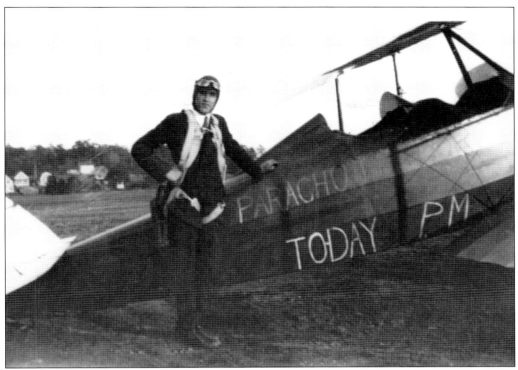

Ivory Marshall Taylor (1911–1973) served in the US Navy until he was honorably discharged in June 1946. He belonged to the Soldier's Service Club in North Vassalboro and the American Legion Auxiliary of North Vassalboro. The Vassalboro Historical Society has two small parachutes and his jumper suit in its possession.

Lewis Percy Cates (1877–1951) always went by Percy. Apparently, this picture was taken when he was young and dressed in some sort of costume. He married Madeline "Mattie" Clark, and they lived in the house across from the East Vassalboro Post Office. He was a gardener and kept a greenhouse at that property. He collected Native American artifacts, which are now owned by the Vassalboro Historical Society.

Four young boys—from left to right, Steven Cates, George Allen Cates, Randall Cates, and Steven Clowes—sing at the Vassalboro Friends Meeting House in East Vassalboro in about 1957. A recent conversation with these now men revealed that they were most likely singing "Jesus Loves Me." All of them lived on Route 32 in East Vassalboro. Steven Clowes is now married to Vassalboro Historical Society president Janice Clowes.

This photograph shows the Albert M. Bradley family. Albert is seated in a chair with arms along with his sons John (seated), Henry (standing on the left), and William (standing on the right). The family ran the Revere House (still standing) in East Vassalboro village. In addition, they owned Bradley's Island; guests at the Revere House would be ferried to the island, where there was a bowling alley, dance hall, and dining room that seated 100. Only the stairs leading up from the lake remain of the lively events held there.

The Campbells Are Coming was put on at the East Vassalboro Grange in 1950 by the 20-40 Club of the Vassalboro Methodist Church. The cast is, from left to right, (first row) two unidentified persons and Aubrey Burbank; (second row) Ina (Hussey) Weymouth, unidentified, Prudence Gray, Harold Wentworth, Alfred Coombs, Ruth Gary, and Arthur Jeffrey.

Harrison Taylor (1816–1902) lived on the Priest Hill Road. The house was later owned by the Noll family in 2014. Harrison was the son of Abner Taylor, who came to Vassalboro from Yarmouth, Massachusetts, in 1799 and built the house. Harrison had three sons—Wilbur, George, and Ernest—and a daughter, Sarah, who married Charles Marden and lived in the brick house on Bog Road.

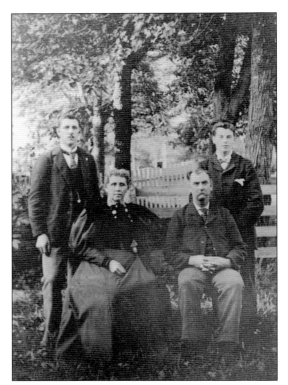

This image shows the Lampson family of East Vassalboro; pictured from left to right are (first row) Annette Ward Bragg Lampson and Hanson Orville Lampson; (second row) Walter Howard Lampson and Edwin Marshall Lampson. Hanson was a harness maker and carriage trimmer. His shop is the building directly across from the present East Vassalboro Grange Hall. The Vassalboro Historical Society has his shop desk and many of his tools.

Harold Cooper Taylor and his wife, Eula May Philbrick Taylor, of East Vassalboro were the parents of Elizabeth "Betty" Taylor. They were married in 1931, and this picture was most likely taken in the late 1930s. They are standing on the south side of their home, which is now owned by the Vassalboro Historical Society.

Five

GETCHELL'S CORNER

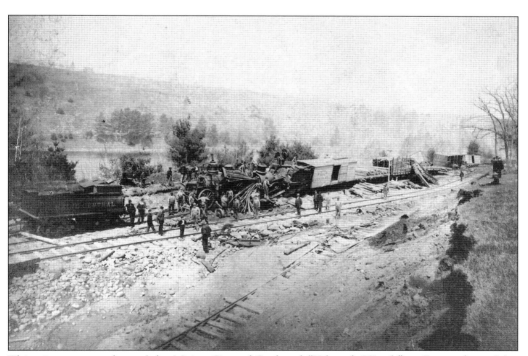

This picture was taken of the Maine Central Railroad "Kilgore's Wreck" in Riverside on May 18, 1883. Trains engineered by Albert E. Kilgore with George Easterbrook (fireman) and Charles Small (engineer) with Wilbur Lawrence (fireman) collided head-on. Lawrence was the only survivor. When engine No. 15 blew up, it is said that the bell was found on the west side of the Kennebec River.

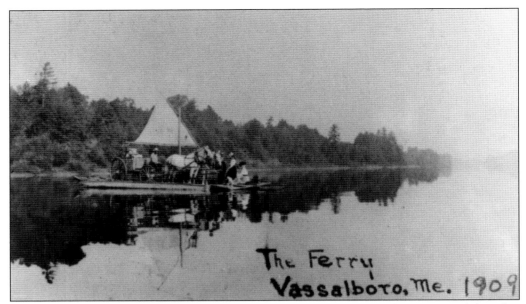

Two ferries connected Vassalboro and Sidney. This ferry was in Getchell's Corner, and the other was stationed at Riverside. The ferryman is Ruel Pitts. The town of Sidney was once a part of Vassalboro, divided by the Kennebec River. Ferries crossed the river in several locations, allowing workers and residents of the town to tend to business. In 1792, Sidney was incorporated as its own town, but the ferries continued to run until the 1920s, primarily to allow Sidney residents to reach the railroad running through Vassalboro.

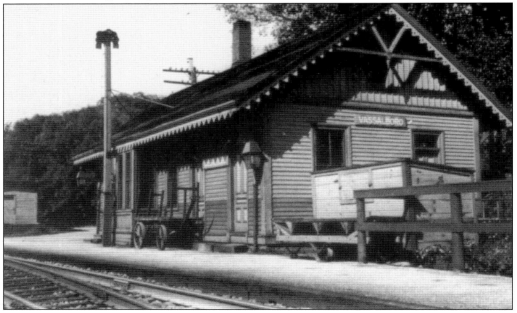

The railroad station at Getchell's Corner was probably one of the fancier-looking stations in town. Although it did not have a protective overhang like its sister station in North Vassalboro, it is obvious from the photograph that much care was taken to make the little stop as appealing as possible. The Vassalboro sign is now part of the Vassalboro Historical Society's collection.

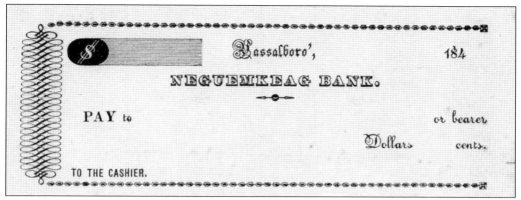

This is a photocopy of a blank check issued by the Neguemkeag Bank in Getchell's Corner. This bank, located in Mary A. Day's home (where the present post office is located), was started sometime in the early 1800s, possibly around the 1820s, and operated until about 1840. Note that "Vassalboro" is spelled with an apostrophe at that time.

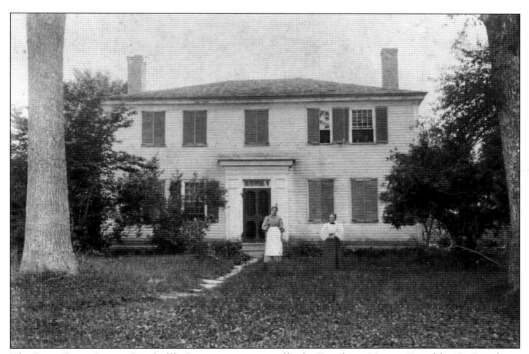

The Rose Croix Inn at Getchell's Corner was originally the Dunham House. Franklin D. Dunham was a boot manufacturer from 1835 to approximately 1880. He employed up to 100 people and made brogans prior to and during the Civil War. His barn burned and he moved the business to just south of the post office.

George Gibson (1836–1910) ran the Gibson Hotel at Getchell's Corner before the fire of 1897. The building behind him to the left was Will Nash's store. The horse and wagon were owned by John Kennedy. The house in the back of the horse and wagon was the Day house, which stood where the present post office is located. The building to the right of the Day house was Fred Day's stable. It is now a house and dwelling.

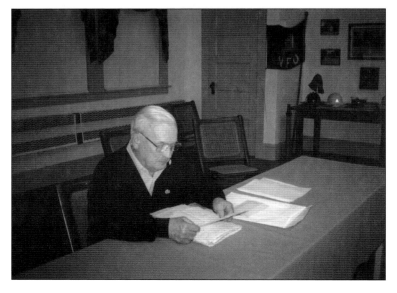

Frank Getchell was born on January 18, 1917, and passed away on October 4, 2015. He was an Air Force veteran from World War II and the owner of Getchell's Apple Orchard and Getchell's Oil Company. Later in his life, he also owned and operated Getchell's Corner Store. Frank Getchell was one of the founding members of the Vassalboro Historical Society.

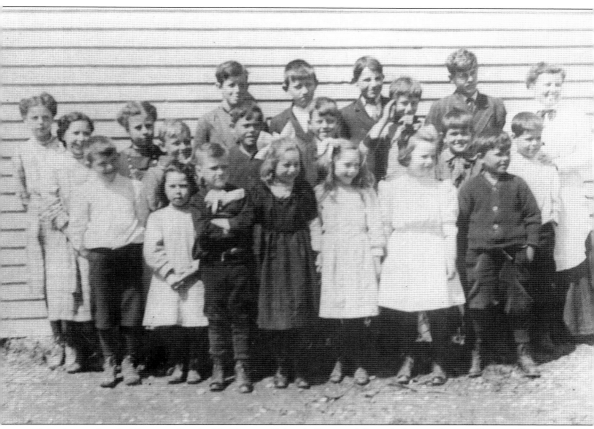

This shows the children at Getchell's Corner School. Pictured from left to right are (first row) an unidentified boy, Grace Jacobs, an unidentified boy, two unidentified girls, Hazel Crosby, and an unidentified boy; (second row) Louise Jacobs, Hazen Gilbert, Loris Rollins, Ernest Gilbert, and Robert Jacobs; (third row) all unidentified except the boy with his hand to his head, Clarence Day, and teacher Alice (Randall) Haynes.

Nettie Burleigh is in front of her fireplace in her dining room. Nettie was born in 1874, the daughter of Hall and Clark Burleigh. A note Clina White wrote on the back of the photograph reads, "Howard and I cleaned out that fireplace many a time. The small chair I have one like it. Miss Potter's nephew gave us the yellow one when Miss Potter passed away over 29 years ago or more. I cooked for them and cleaned the house on Saturdays while Howard did the groundwork and milked 'Midget' the old cow." The photograph below shows Nettie with "Old Midget."

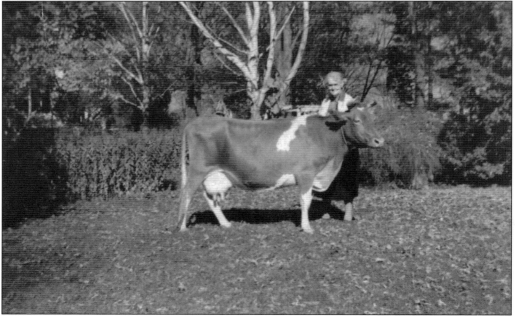

Six
NORTH VASSALBORO

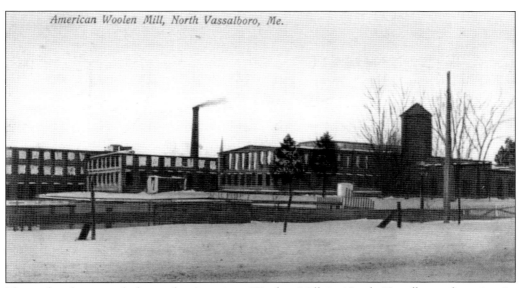

This colored postcard shows the American Woolen Mill in North Vassalboro, featuring its three brick buildings. The North Vassalboro Woolen Mill was added to the National Register of Historic Places in the State of Maine on October 5, 2020. The Vassalboro Historical Society has lots of information regarding the mill, as it has always been a great source of pride for the town.

The North Vassalboro Woolen Mill's top floor, No. 1 mill, is the oldest part of the mill complex. It was originally known as the Weave Room. Many textile pieces from this mill can be found at the Vassalboro Historical Society to this day, along with information about the machines used to make them.

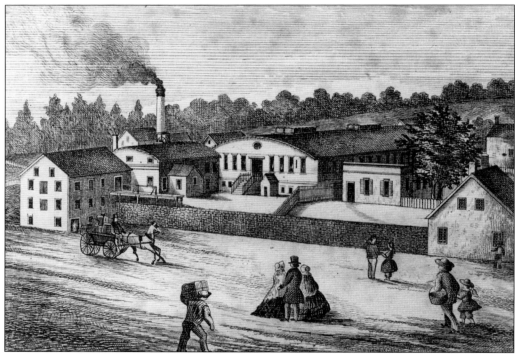

A detail from the 1856 Wall Map of Kennebec County shows the woolen mills of the North Vassalboro Manufactory Company. This lithograph shows pedestrians and traffic near the woolen mill in North Vassalboro. Cassimere, a woolen fabric manufactured here, won first prize at the 1850 World's Fair in London, England. The building currently serves as one of the town's community hubs.

Photographed here is the northeastern end of the American Woolen Mill buildings and part of Route 32. This photograph was taken by Steven Burbank about 1953, two years before the mill closed in October 1955. It included a note saying that the water rights go with the mill. Auctions on the machinery and equipment were held a year later, on July 25, 1956.

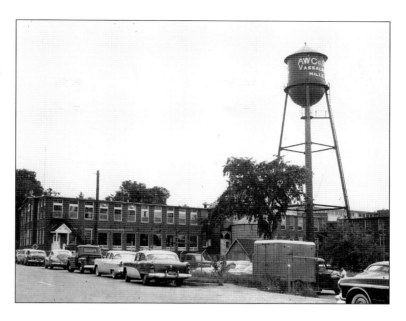

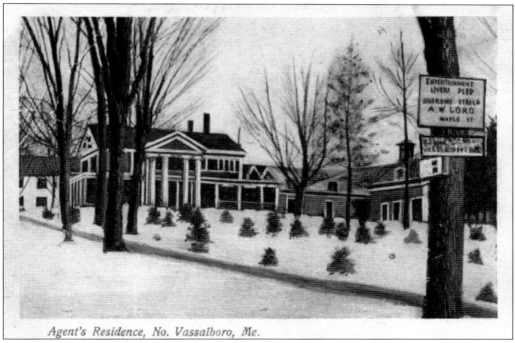

Agent's Residence, No. Vassalboro, Me.

The Mill Agent's House still stands on Priest Hill Road in North Vassalboro to this day. Due to its long, and sometimes sad, history, it has been the site of many paranormal investigations. It is owned, with the mill itself, by Raymond Breton of Vassalboro and used as an apartment complex.

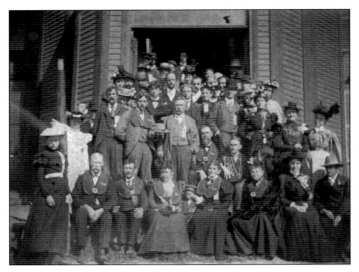

The Good Templars are shown in North Vassalboro at Citizen's Hall in about 1898. The International Organization of Good Templars was founded in 1851. Their main principle is to teach others about leading a life free from alcohol or drugs. This is taught through service to communities and societies throughout the world. The Good Templars were organized with inspiration from the Freemasons; however, they are completely different organizations.

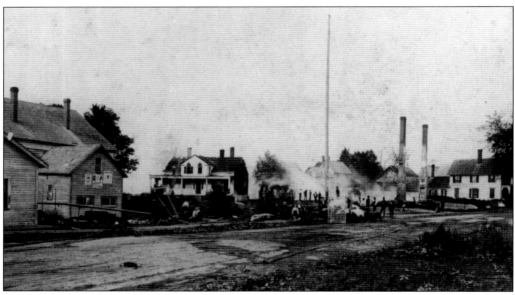

This print shows a scene of the Murray Hotel fire in 1890. All the contents were lost as well as two stables, two dwellings, a carriage house, and an icehouse. The houses were owned by George Hawes, with John Doughtery residing in one of them. Waterville had to be called to help Vassalboro put out the flames. George Hawes was only half insured for $1,500. Although an article in the *Maine Farmer* on July 26, 1894, stated that the hotel structures would probably be rebuilt, they were not. Later, the American Legion building (now a private home) was erected on the site.

Frederick "Freddy" Pullen's house was located on Cemetery Street in North Vassalboro. Frederick owned Freddie's Service Center garage in East Vassalboro and later handed it down to his son, Bill Pullen. The couple in front of the house are unidentified. It is believed that he bought the garage sometime between 1959 and 1960. The original structure burned down in 1999 but was quickly rebuilt after approval from the town. Freddie's is still a thriving business to this day in Vassalboro.

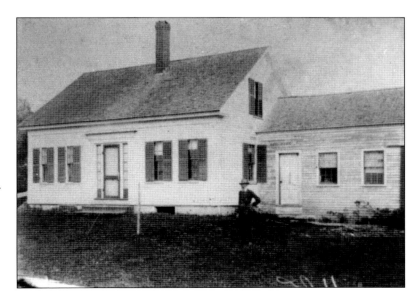

This photograph shows the George Spear Roundy homestead, which stood by the lake at East Vassalboro and was moved to North Vassalboro. It is now located on St. Bridget's Way, behind St. Bridget's. It was moved when the water district was established at China Lake. George Roundy stands in front of the house.

This brick house on the east side of Main Street was once owned by the Ruth Copper Brackett family. Ruth became a skilled quilter and was also a volunteer for the Vassalboro Historical Society. Ruth and her husband, Roy, were board members of the society. Roy was considered one of the "Three Amigos" who worked tirelessly on construction projects under the lead of building director David Bolduc.

This photograph was taken when the Ayer District School was moved from its location on Oak Grove Road near the intersection with Taber Hill Road to North Vassalboro Village to become the American Legion hall. More than a dozen men helped tow it to its new location. The Lowell School in North Vassalboro opened in 1872 with larger classrooms and a large auditorium. It was used for classes until 1962.

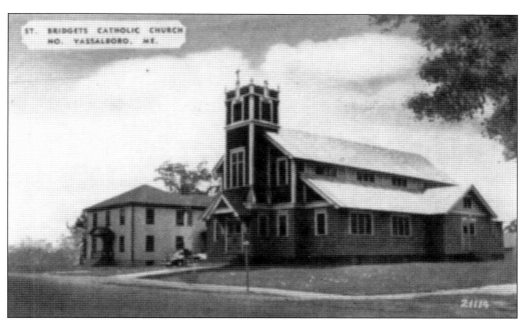

St. Bridget's Catholic Church and Parsonage, on the west side of Main Street in North Vassalboro, was first built in 1874. A fire destroyed the first building in November 1925, and a new church was built in 1926. It was in continued usage until 2011, when a merger caused the building to shut its doors. It was later brought back to life when Rachel and James Kilbride bought the property in 2015.

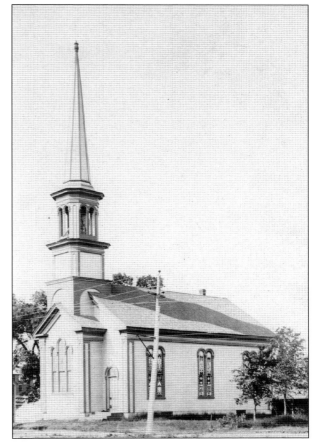

The North Vassalboro Baptist Church was dedicated on January 7, 1874. The Free Baptists of North Vassalboro were organized in November 1870 and led by Reverend Bean. Until the building for the church itself was erected, services were held in the Union Meeting House. It is believed that most of the early records for the church are missing due to a fire at the clerk's home.

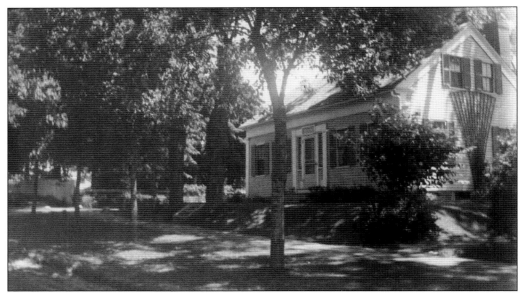

The Jonathan Nowell homestead is located on Priest Hill Road in North Vassalboro. It used to be known as Dearborn Hill Road, but the road was discontinued and is now known as Dearborn Hill Court. This home was later owned by his granddaughter Hope Homans Clark and is currently owned by Robert and Cynthia Shorey. This photograph was taken in 1965.

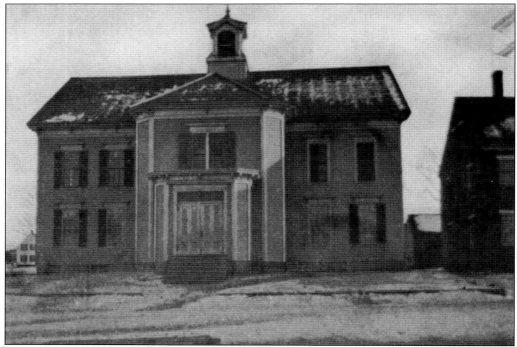

This photograph shows Citizen's Hall on Main Street in North Vassalboro. This building served as a grammar school for many years. In the 1950s, it became the town office. Dr. John Burke opened an office on the right side of the building, probably in the late 1970s, later becoming the Mid-Maine Internal Medicine office serving the entire region. It is currently for sale.

This photograph shows the old North Vassalboro Post Office when it was located in the building later used by Howard Crosby as a television repair shop. It was a vacant building by 2006. Due to Vassalboro growth, the original building was outgrown. The post office was later moved to where it now stands at 847 Main Street. The postmaster at the time was Gerard Belanger.

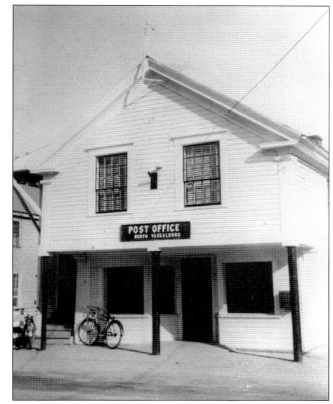

This photograph shows a house being moved from North Vassalboro to Gray Road. Taking three teams of horses led by three unidentified men, with the two-story building rolling on logs, this was an amazing undertaking. This project required both skill and stamina, replacing each log from back to front as the house rolled forward.

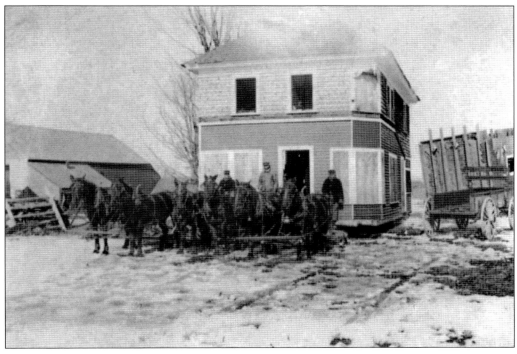

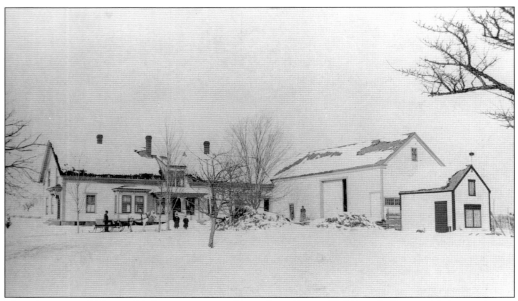

The George and Emma Taylor property is located on Priest Hill Road. George Taylor is shown by the sleigh with his wife, Emma, near the barn. Their daughters, Ida and Grace, are shown in front of the porch. This house, built in 1881 by George Taylor, was later owned by Taylor's nephew Alfred Taylor and Alfred's wife, Mildred. It burned down in 1980. Richard Breton has built another house on this site.

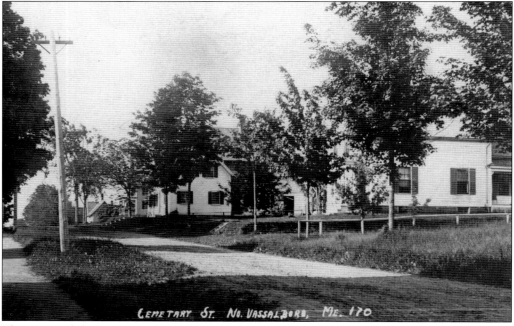

This postcard shows a scene from Cemetery Street in North Vassalboro. This road runs along the Outlet Stream on the opposite side of Main Street. While there are many cemeteries in Vassalboro, the North Vassalboro Cemetery is found here. Many of the Vassalboro men who fought in the Civil War are buried in this cemetery.

This photograph shows part of four corners at North Vassalboro looking west on Oak Grove Road. On the second floor of the building in the forefront is the Masonic hall. The lease is in perpetuity as long as there is an active Masonic lodge. The building to the left of the photograph is no longer there.

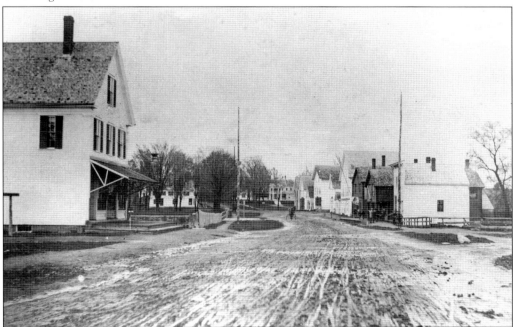

Bridge Street, in North Vassalboro looking east, is now Oak Grove Road. The white building in the left foreground was the former Hutchinson's Drug Store. In the middle of the photograph is the Mill Agent's House, a beautiful building currently in use as an apartment building rumored to be haunted. This clearly shows that it was mud season.

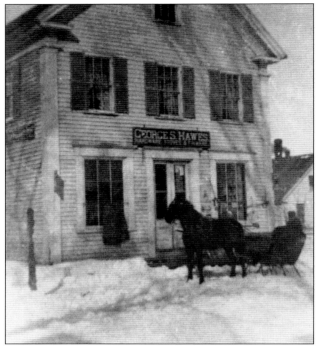

These photographs show interior and exterior views of the George S. Hawes Hardware, Stoves, and Tinware Store, located on Bridge Street, now Oak Grove Road, in North Vassalboro. The people are, from left to right, Willard Marriner, Nellie Marriner, Jack Dougherty, and Alton Rancourt. The building was later home to Robert and Lorraine Bragdon and is the current home of Lisa and Samuel Weston and family. The Westons have found vintage artifacts in the walls of their home during remodeling including baseball bats, shoes, and bottles. They donated a bottle of Milliken's Parlor Pride Trademark Stove Enamel to the Vassalboro Historical Society. The Hawes store was one of many in North Vassalboro that served the needs of the village and the surrounding community.

This photograph was taken of a North Vassalboro, Maine, confectioner's store in 1941 with an unidentified woman and child. Note how Pepsi-Cola is being sold for 5¢ at the time. The store offered Frojoy ice cream, which was sold on the shores of China Lake by a Vassalboro family.

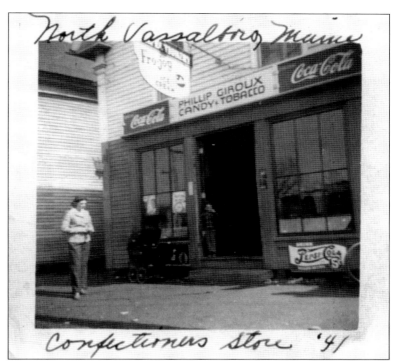

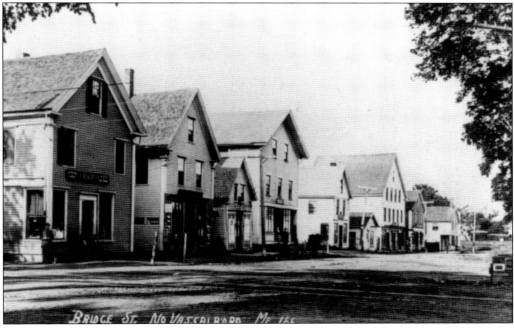

Oak Grove Road connects Main Street to Route 201 in Vassalboro. It is home to the Maine Criminal Justice Academy, Oak Grove Cemetery, and the Sophia D. Bailey Chapel. In an article in the *Daily Kennebec Journal* on February 27, 1984, it was reported that the Oak Grove Seminary and Bailey Institute at Vassalboro was made the recipient of a fine bell for the belfry, with the donor being Eleanora S. Woodman of Portland.

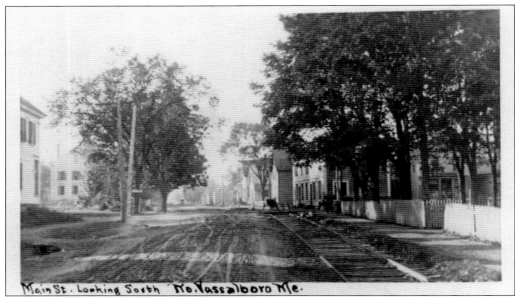

A street view of Main Street in North Vassalboro looks south depicting trolley tracks. These tracks followed Route 32 from East Vassalboro through North Vassalboro to where the Bassett Road meets Route 32. At the brook, looking west, one can see the abutments for the old auto bridge, but the current bridge was the trolley bridge.

A street view shows the duplex homes built by the American Woolen Mill for its employees. This photograph was taken from the four corners near the mill and looks north. Notice the automobile in the distance, raising a cloud of dust as it approaches. While mill workers were typically from Vassalboro themselves, after the American Woolen Mill Company took over the mill, workers were brought in from numerous towns all over the state, as well as from other countries, and needed living quarters.

James White was a Civil War veteran whose diary is in the historical society's collection. The first entry was April 16, 1863, and reads in part, "Pleasant in the morning but towards night clouded up and now bids fair for another storm. We are waiting anxiously for tidings from Charleston and also from our cavalry which broke camp day before yesterday morning. Much depends upon Hooker's first move. May fortune favor him."

This photograph shows Vassalboro Fire Department members Herbert Ferran (in the truck) and Abbot Cates (in the slicker). The Vassalboro Fire Department was founded on February 17, 1935, and was then named the Legion Fire Department. An extreme fire ravaged the town on November 11, 1934, forcing Vassalboro to ask for help from nearby towns at great cost to the town. It was then the residents knew they needed to start their own department.

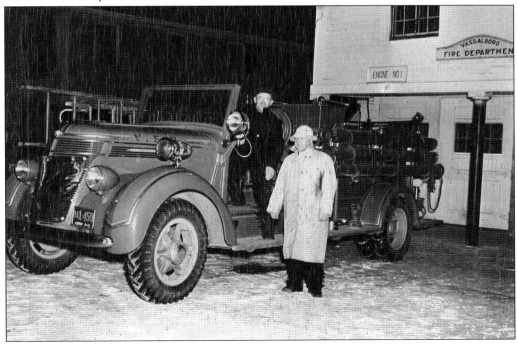

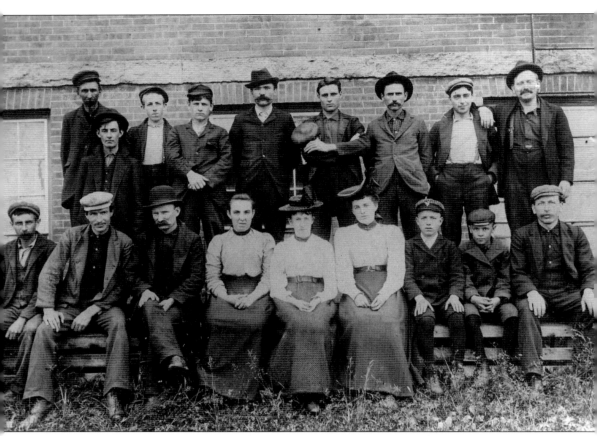

This photograph shows employees of the Spinning Room at North Vassalboro Woolen Mill in 1885. From left to right are (first row) James Marden, Fred Downer, William Lyond, Ella Goodson Murphy, Eva Hurtley, Annie O'Keefe, William O'Keefe, Robert Soucia, and William Hurtley (overseer); (second row) John Allen, Fred Pooler, James Flynn, John Clapperton, Michael "Conroy" Murphy, Archie York, Edward Penley (or Perley), Wilbur Lewis, and John Seaney.

An American Legion meeting is being held sometime around 1946. From left to right are (first row) Carleton Fournier, Alcide Poulin, Harold Tobey, Jasper Shorey, and James Gratto; (second row) unidentified, Alton Rancourt, Arthur Gilbert, Clyde Gilbert, and John Smedberg from Winslow. The American Legion post in Vassalboro was founded in 1922 by Joseph Archie Dyer (US Navy, 1917), Carl B. Lord, (ensign, US Navy, 1917), and Robert Clapperton (US Army, 1917) and was named the Ronco-Goodale Post No. 126.

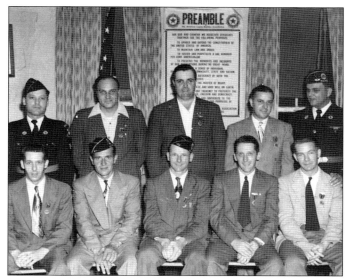

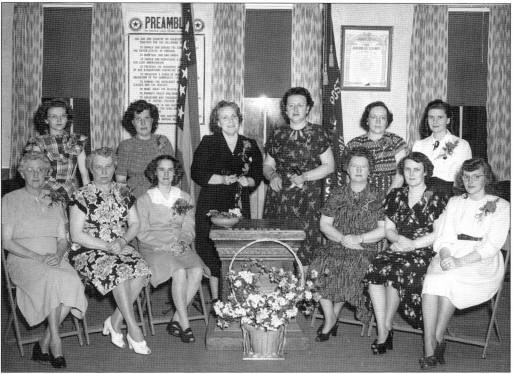

This photograph shows an American Legion Auxiliary meeting. From left to right are (first row) Madge Wyman, Christine Hawes, Helen Gratto, Beatrice Hussey, Norma Cates, and Leona Dyer; (second row) Virginia Gallant, Renee Fournier, Katherine "Kay" Stewart, Elsie York Tobey, Jennifer "Jenny" Fisher, and Mary Hussey Sibley. The Town of Vassalboro gave the Legion a gift of a small school building as a war memorial, and the Legion purchased a vacant lot about one and one-half miles away. Although the building still exists, it is no longer the Legion hall. The American Legion members continue to meet at a local community center.

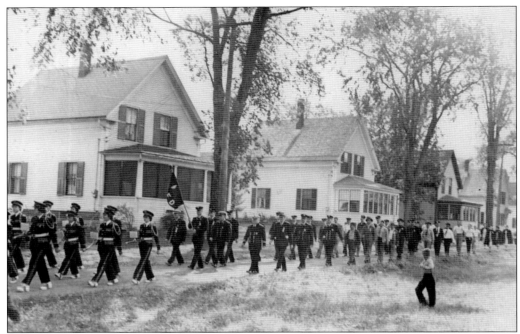

A parade marches on Lang Street in the 1960s. There was always a good turnout of Vassalboro residents at the parades. The parades included majorettes, marching bands, floats created by local organizations, Scout troops, the fire department, and antique cars and trucks. Memorial Day, Fourth of July, and Fireman's Field Day were the annual parade days.

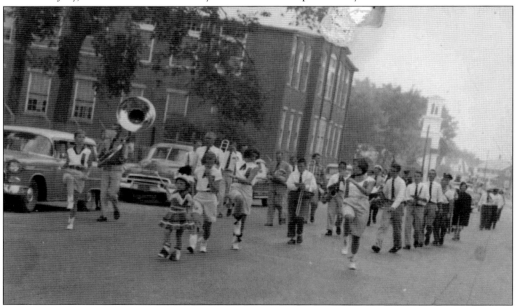

This photograph of Fireman's Field Day was taken on August 10, 1957. The girls are identified from left to right as Carol P., Barbara "Barbie" E., Nancy C., Jane W., and Patricia "Patty" Smith. The first Fireman's Field Day was held on May 27, 1935, as a way to raise money for the newly founded fire department, and it was an annual affair for many years.

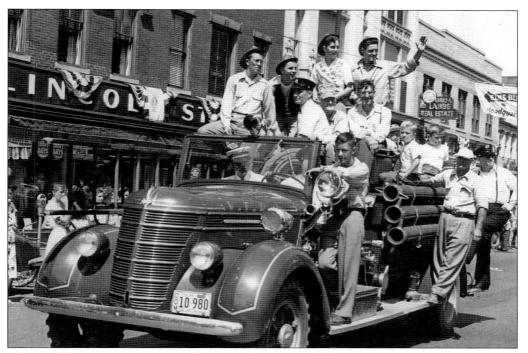

The Vassalboro Fire Department rides its truck in Waterville's 150th anniversary on Main Street in 1952. The riders included both regular volunteers and junior firemen. In front, Chief Walter Beaulieu is next to the driver, Norman Duplessie. From left to right are (on the top of the truck) Mickey Lemieux, Edward Poulin, Willard Street, and Charles Walker; (middle of the truck) Benjamin "Bennie" White, Herbert Witham, and Kenneth Buzzell; (hanging on the sides) Paul Duplessie, Howard Percy Crosby Jr., and Joseph Cosgrove Sr.; the two children are Peter and James Bragdon.

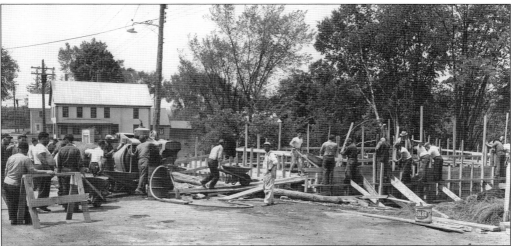

The new Vassalboro Fire Department was constructed in 1949. This was built entirely by local Vassalboro firemen, with help from the Ladies' Aid. The dedication ceremony for the building was held that September. A news article about this event can be found in the library of the Vassalboro Historical Society.

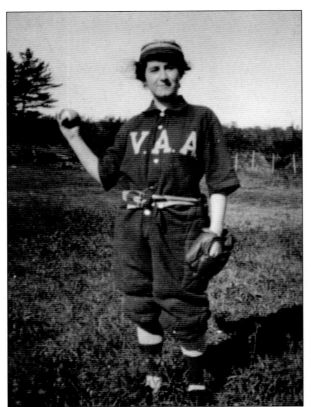

Katherine "Katie" O'Keefe, later Ribbons, pictured around 1912–1914, is dressed in her brother Daniel O'Keefe's Vassalboro Athletic Association baseball uniform. Katie was born on December 11, 1891, and passed away at the age of 107 on December 11, 1998. She was a member of St. Bridget's Church, the American Legion Auxiliary, and the Vassalboro Historical Society.

The Vassalboro Athletic Association team of 1912–1914 is made up of, from left to right, (first row) Arthur Allen, Arthur Gilcott Sr., William O'Keefe Sr., Danny O'Keefe Jr., Earl Goodwin, and Harold McCray (bat boy); (second row) William Carlender, Warren Staples, Daniel Staples, manager John O'Reilly, Fred Duplessie Jr., and James Staples. This photograph was taken on the steps of the American Woolen Mill Company's agent's house on Bridget Street, North Vassalboro.

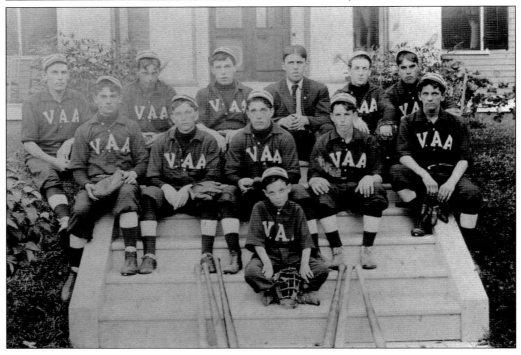

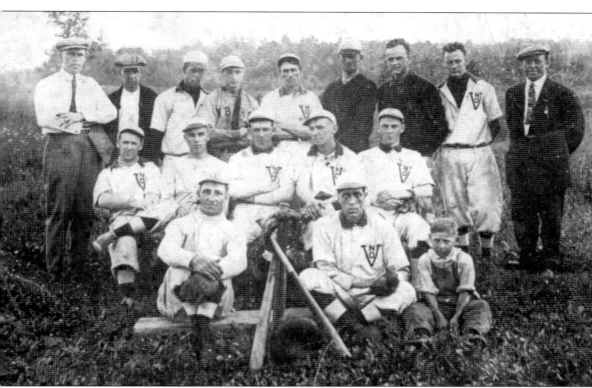

The North Vassalboro baseball team is pictured in about 1913; from left to right are (first row) William Scott, William Socia, and Dwight Manson; (second row) Fred Duplessie, Daniel Staples, Horace Fisher, Victor Verkruysse, and Charles Dusty; (third row) John O'Reilly (scorekeeper), James Staples, Warren Staples, unidentified, Harvey Lachance, John Manter (coach), William Manter, and Edgebert Farnham, with Charles Piper (umpire).

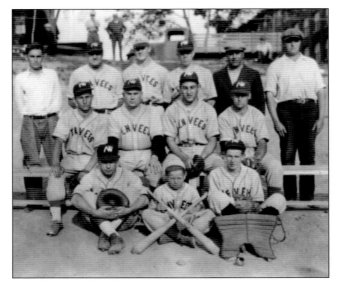

The North Vassalboro Envees baseball team of 1934 was made up of, from left to right, (first row) Raymond O'Keefe (shortstop), Frank "Skippy" Chapman (bat boy), and Clarence "Goog" O'Keefe (second base); (second row) Benjamin Perry (third base), Norman Lachance Sr. (catcher), Thomas Maroon (center field), and Theodore Perry (pitcher/left fielder); (third row) John Gallant (equipment manager), Alton "Ranny" Rancourt (first base), Webber "Webbie" Manter (pitcher), Ronald "Gut" Gulliver (right field), John Halaley (manager), and Arthur Gilbert (scorekeeper).

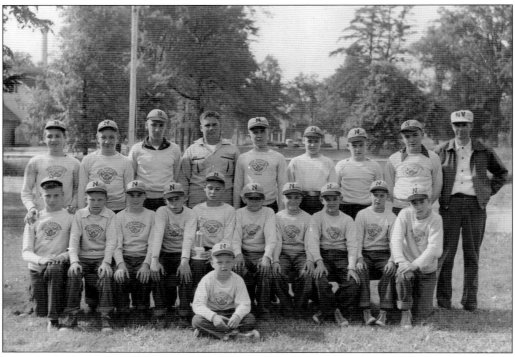

The North Vassalboro Grammar School League is pictured here; from left to right are (first row) James Gratto Jr.; (second row) Warren Neil, Donald Duplessie, Leonard Gilbert, Donald Dion, Richard Saucier (captain), James Adams, Harvey Dutil, Rodney Rogers, Glenn Carnegie, and Joseph Cosgrove; (third row) John McLean, Thomas Murphy, Roland Buzzell, Daniel Williams, Sonny Lessard, James Walker, Kenneth Buzzell, Robert Lemieux, and Clarence "Goog" O'Keefe (coach).

This photograph shows the Lowell Grammar School team. The Lowell Grammar School, also known as the North Vassalboro Grammar School, was built in 1873. At the time, the building was situated right up against the road. However, sometime around 1910–1912, the building was pushed back away from the road and other homes. The structure still stands today on Main Street in North Vassalboro.

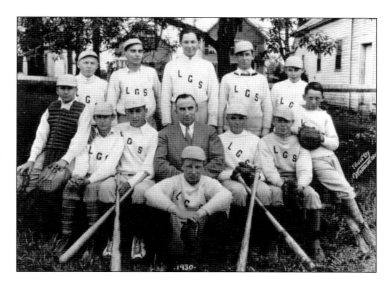

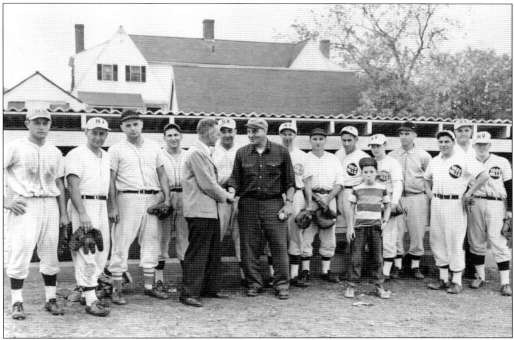

This picture was taken in 1948 of the Vassalboro Mills team in North Vassalboro. This was the first year uniforms were used for the team. Pictured are, from left to right, (first row) Don Newell, president of the league, Alton Rancourt, manager, and Joe Cosgrove Jr., bat boy; (second row) Maurice Mathieu, Benjamin Perry, Gerald Poulin, Steven Masse, William Harrington, Clarkence O'Keefe, Leo Ouellette, Emelien Gagne, Donald O'Keefe, Vincent "Stuffy" MacGinnes, Paul "Pee Wee" Masse, scorekeeper Arthur Gilbert, and Dana Soule.

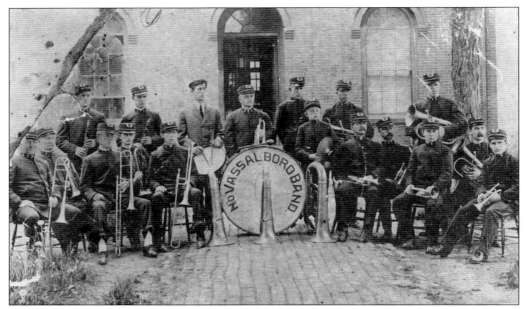

The first row of the North Vassalboro Band includes William Lyons, Charles Piper, Merle Wyman, Elmer Merchant, Archie Steelbrook, Thomas Fitton, and Rod Lyons; four people in the first row are unidentified, and it is not known which four. Please contanct the Vassalboro Historical Society if you recognize a relative in the group. The second row is, from left to right, Harry Hawes, James Staples, Chester Perry (drum), Mahlon McCurdy (cymbals), Hillman, William O'Keefe, and John O'Reilly (bass horn). The band was established around 1907 and led by Billy Sommers.

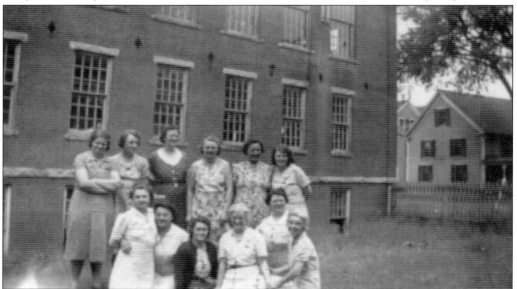

The American Woolen Mill Sewing Room group is shown here; from left to right are (first row) Amy Lemieux, Elsie Daugier, Loretta Shorey, Alice Stone, Daisy Sampson, and Annie Dougherty; (second row) Mabel Bragdon, Gladys Grant, Celia Kent, Lilla Smith, Claudia Perry, and Mae Cooper. Before the mill was sold to the American Woolen Company, it was run entirely by local Vassalboro workers.

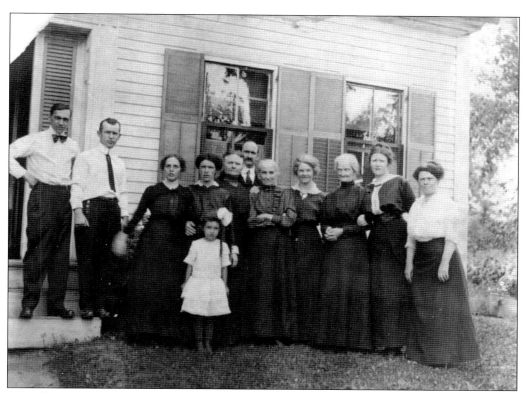

A North Vassalboro extended family group is pictured; from left to right are Vern Merriam, Herbert Farran, Sarah Merriam (Vern's wife and Herbert's sister), Lucy Wigglesworth, Alice Farran Stone (mother to Lucy Wigglesworth), John Farran, Gladys Stone Wilcox, Jane Farran, aunt Sarah Merriam, Helen Deely, and Sarah Herbert; the little girl is Mame Herbert.

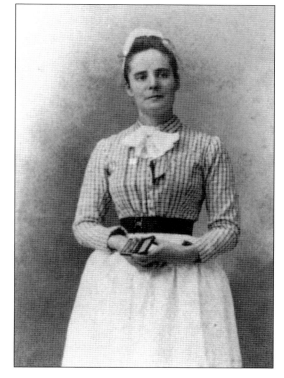

This is a photograph of Greta Mabry, who was the daughter of Dr. Charles Mabry of North Vassalboro. Charles Mabry practiced in Vassalboro for 42 years and died at the age of 77 in 1930. Greta Mabry became a nurse and a teacher. She was also recorded as the assistant superintendent for the Massachusetts Children's Asylum.

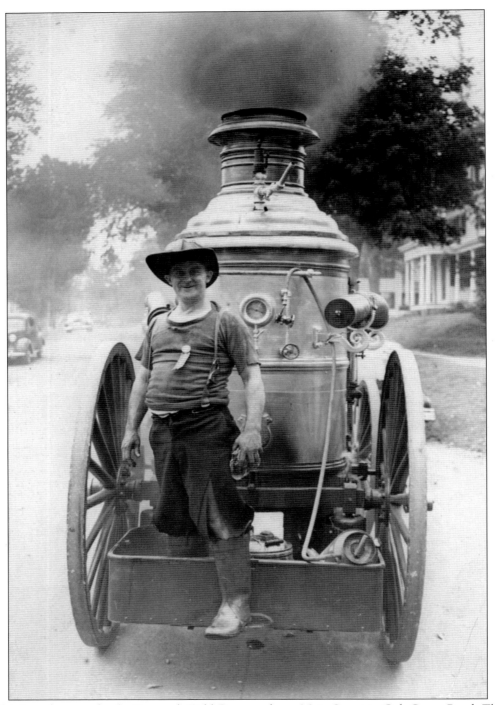

This is a photograph of a Fireman's Field Day parade on Main Street to Oak Grove Road. The fireman with the old apparatus is unidentified. (If you know who this fireman is, please contact the Vassalboro Historical Society so it can update its information.) Research shows that this may be a 1902 Hubert Steam Fire Engine.

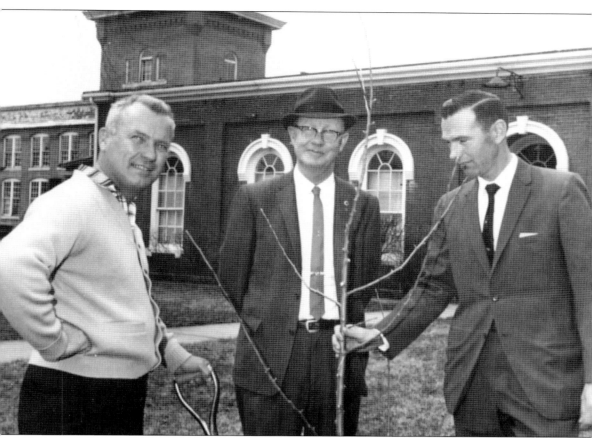

Pictured from left to right, Frank Getchell, Norman Fossett, and David Bolduc were all presidents of the Vassalboro Historical Society. This photograph was taken at the planting of the Starkey apple tree on the lawn of the society's museum at North Vassalboro in the summer of 1967. The Starkey is the only apple to have originated in Vassalboro.

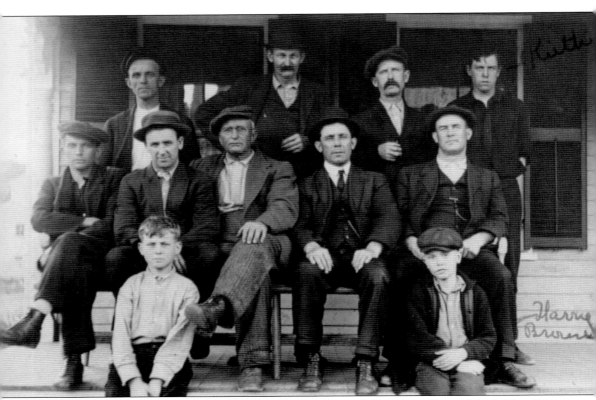

A postcard from June 15, 1916, shows residents of Brown's Boarding House, North Vassalboro. On the front is a picture of a group of nine men and two young boys. One of the men is identified by the first name of Keith, and one of the young boys is identified as Harry Brown.

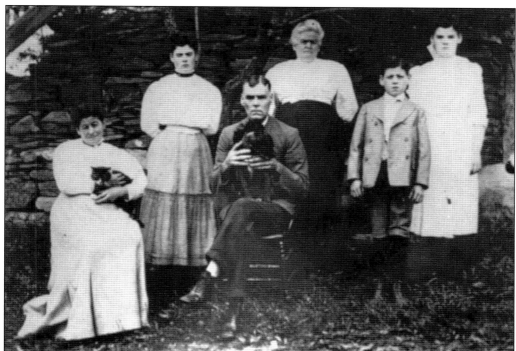

The Brown family lived on Maple Street in North Vassalboro. Pictured from left to right are daughters Irene Brown and Lottie Brown, Ira E. Brown, Margaret Brown, son Hugh Brown, and Margaret's sister "Aunt Lizzie" McKerney. This stonework appears to be around the kitchen, as their house had the kitchen in the basement.

Ruth Priest (1920–2011) was the daughter of George and Myrtle Smith Priest. Her father had been North Vassalboro's milkman since August 1, 1908. Ruth herself graduated from the Lowell Grammar School in North Vassalboro in 1934. She was a member of the Vassalboro Friends Club, the North Vassalboro Baptist Church, and the Vassalboro Historical Society.

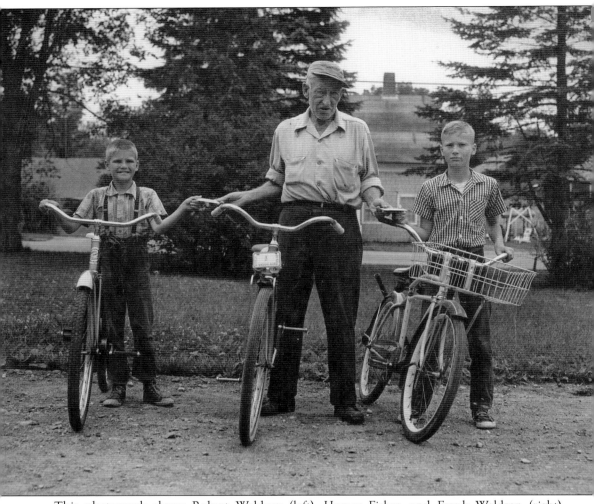

This photograph shows Robert Waldron (left), Horace Fisher, and Frank Waldron (right). Horace and his wife, Eugenie, became guardians of the boys and their older sisters, Pamela and Linda, when their parents died. Horace provided the bicycles for the boys and taught them all to hunt, trap, and tan hides, and build bridges over the stream. The children were with the Fishers for more than five years before Horace died and they moved in with their grandparents in Center Vassalboro.

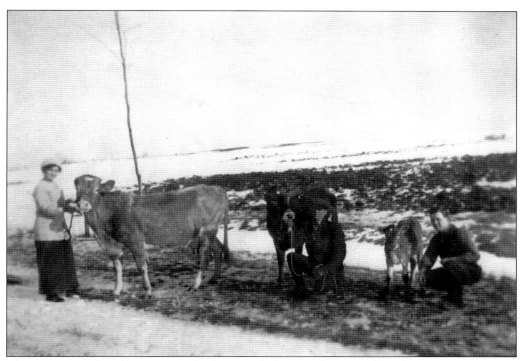

This is a postcard made from a family photograph showing three people and three cows. This was taken on Ernest Priest Farm on Priest Hill Road in North Vassalboro. Clara the cow is on the left. Clara had an article written about her due to her impressive milk production. It is said she was "not being pushed for a record" but rather this was her production on a normal day.

Adam Seaney, a North Vassalboro mail carrier, wears a heavy fur coat and hat by the drinking fountain in front of the American Woolen Mill office. This photograph was taken in the winter—one can see that Seaney is being pulled on a sled through the snow rather than a carriage.

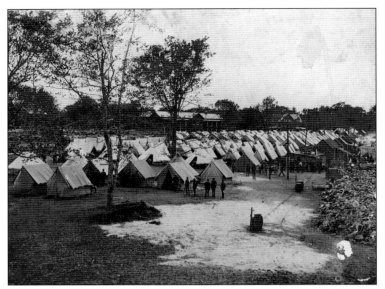

This photograph of a soldier encampment, Camp Thomas, is from Fredrick Thorndike, who served at Chickamauga in Georgia during the Spanish-American War. He was part of Company H, 1st Maine Volunteer Infantry. The building in the center was the Bachelor's Quarters. The battle of Chickamauga was September 18–20, 1863; it was the largest Confederate victory in the western theater.

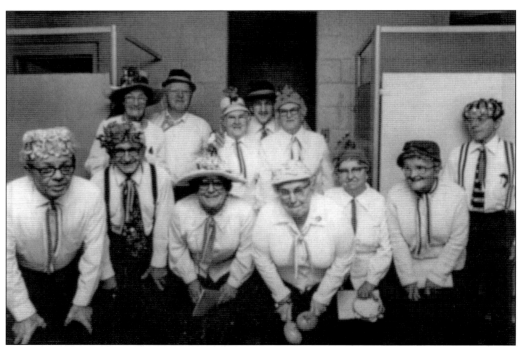

The Puddin Head Band and Vocal Group was a band and singing group from the Vassalboro Senior Citizens. The photograph was probably taken in the late 1970s. The members are, from left to right, (first row) Emil Duplessie, Louis (or Lewis) Poulin, Georgianna "Georgie" Cain, Paula Richard, Christine Duplessie, Edith Shorey, and Edward Doe; (second row) Evelyn Wooley, Silas Cain, Madeline Jones, Dudley Foley, and Frances Carl.

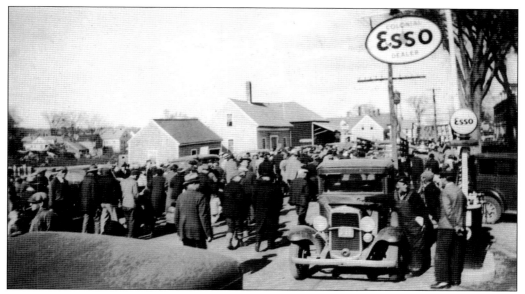

A crowd of people stands in the street in North Vassalboro, most likely for the auction of the properties of the American Woolen Company. This photograph was taken on Saturday, October 18, 1935. The man in overalls next to the car is Herbert Ferran, a blacksmith, and the man in the lower left of the photograph is Albert Adams.

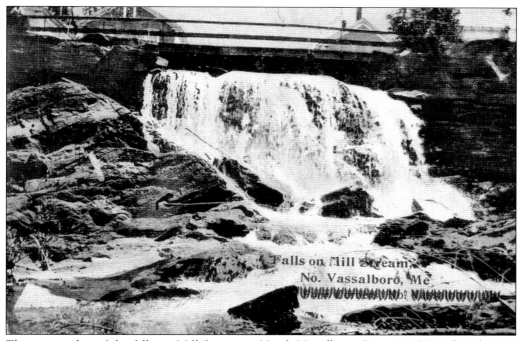

This postcard is of the falls on Mill Stream in North Vassalboro. Begun in 2019, the Alewives Restoration Project was completed in 2022. Alewives (also known as river herring) had not been in Vassalboro since 1783, when dams began blocking their natural route. Scientist Nate Gray started his public outreach for the project in 2000–2001 with the China Lake Association.

This old house on Priest Hill Road was owned by Gustavus and Mary Taylor Priest. Gustavus (1835–1885) and Mary (1850–1884) are both buried in the Priest Hill Cemetery. Ernest C. Taylor bought this property from the Gustavus Priest Estate in the late 1890s. Ernest and Gertrude built a new house just north of this house in 1909. This house eventually became a blacksmith shop for Ernest and Gertrude's oldest son, Harold.

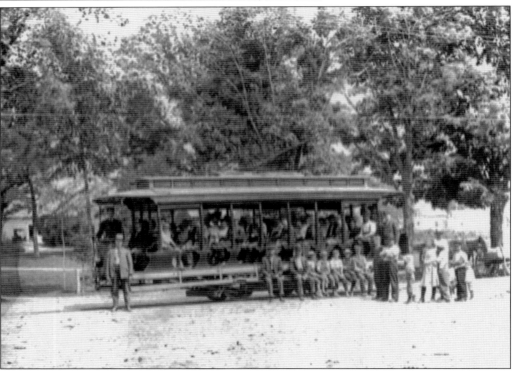

This is a photograph of the first trolley (or electric car) to come through the four corners at North Vassalboro. A little bit of the woolen mill agent's house can be seen in the left background. It was a busy and exciting time for Vassalboro residents, as they could now use public transportation to get from Vassalboro to Waterville, Augusta, and Lewiston.

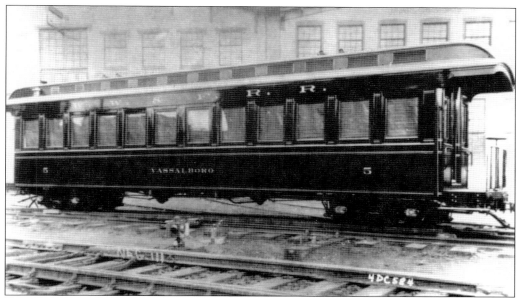

Coach No. 5, named "Vassalboro," was manufactured in 1903 by Jackson & Sharp Foundry in Wilmington, Delaware, for the Waterville, Wiscasset & Farmington Railroad (WW&F). This narrow-gauge passenger car is pictured beside a standard-gauge track. The observation platform (on the right) indicates that this car was located at the end of the train. Historian Elizabeth "Betty" Taylor remembered that the WW&F was dubbed "Weak, Weary & Feeble" by locals.

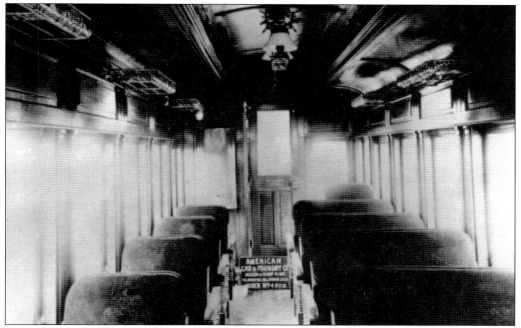

On the narrow gauge, everyone had an upholstered and comfy window seat. The seatbacks were flipped when the direction of the car reversed so no one had to ride backward. Less obvious is the "poop hole" near the end of the car, a private "one-holer" for passengers to use as the rails flew by below. Ten minutes before a station stop, the facility was flushed and locked.

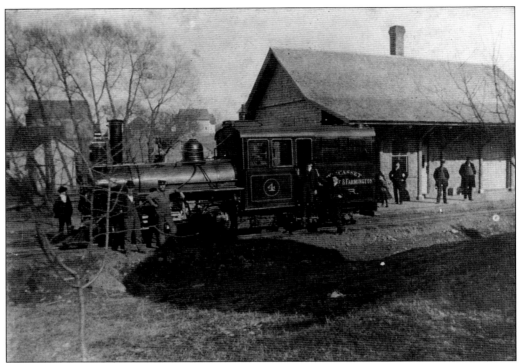

This photograph shows the narrow-gauge railroad station on Oak Grove Road. The little girl just behind the engine is Annie Dougherty. John Dougherty Sr. is second from right, and James Staples is at far right. This station operated from 1902 to 1915 and ran all the way from Wiscasset to Albion.

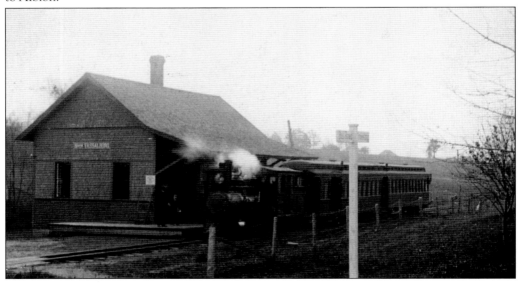

The North Vassalboro Train Station operated from 1902 to 1915. The American Woolen Mill was one of its major customers; however, the cancellation of its coal-hauling contract shut the whole line through Weeks Mills, South China, East and North Vassalboro, and Winslow down. Until 1912, its main route was from Wiscasset to Winslow.

Seven
OAK GROVE

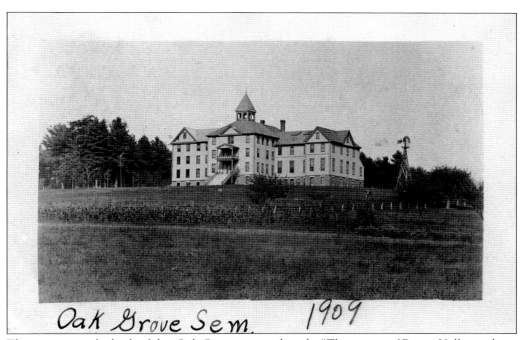

The caption on the back of this Oak Grove postcard reads, "The towers of Briggs Hall rise above the hilltop in the midst of Oak Grove's one hundred and fifty acres, commanding a sweeping view of the entire horizon. Stately pines and patriarchal oaks mingle their branches in a protecting grove on the north of the school buildings while the smiling Kennebec River winds far down the picturesque valley in front."

LIBRARY, BRIGGS HALL, OAK GROVE SEMINARY, VASSALBORO, MAINE

Oak Grove Seminary was a school founded in 1848 by Quakers for their children. The original building was destroyed by a fire in 1880, but a new one was erected in 1885. That building, however, was also destroyed by an arsonist in 1887. Another was built in 1888. Oak Grove Seminary became an all-girls school in 1925. This continued until 1972, when Oak Grove combined with Coburn of Waterville for financial reasons. This merger led the school to become coeducational once again until its eventual closure. The structure has remained a school for much of its lifespan and is now the Maine State Criminal Justice Academy.

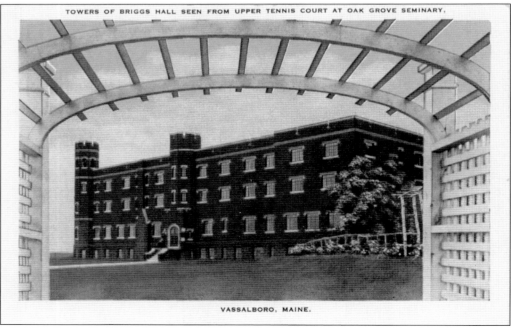

TOWERS OF BRIGGS HALL SEEN FROM UPPER TENNIS COURT AT OAK GROVE SEMINARY, VASSALBORO, MAINE.

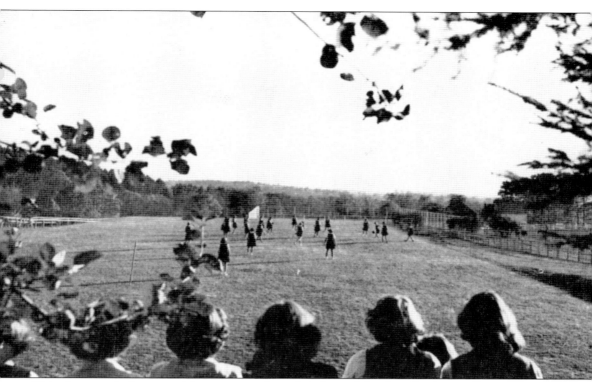

This photograph shows a girls' soccer team from Oak Grove School in North Vassalboro playing on their field with a group of ladies sitting on the sidelines. The back reads, "Oak Grove had 300 acres of fields and forests with bridle paths and spacious playing fields—Gannet Field in the foreground, five tennis courts beyond, a riding ring at right."

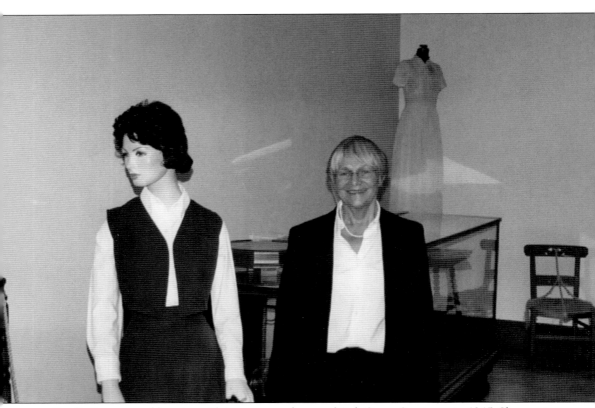

Estelle Parsons and her sister Elaine were graduates of Oak Grove Seminary in 1945. She went on to become an actress, starring in various stage and screen roles, including as Roseanne's mother on both *Roseanne* and *The Connors*. A letter of recommendation states that Estelle is "forthright, industrious, energetic, objective and friendly, with a real interest in intellectual work and an unusual capacity for executive responsibility." This photograph was taken when she visited the historical society. She graciously donated some school items to the museum.

Eight
RIVERSIDE

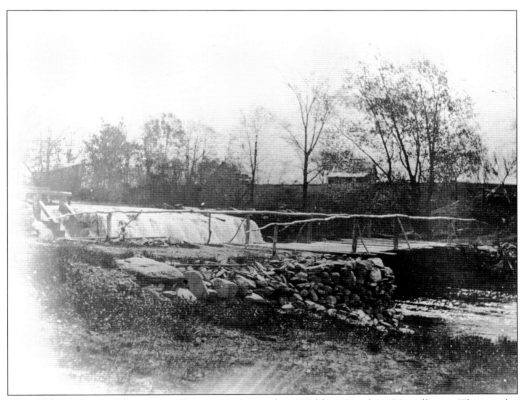

The Old Bridge and Reservoir Dam were located at Webber Pond in Vassalboro. This is the source of Seven Mile Brook. The photograph was taken around 1900 and looks east toward Rowe's Point, with homes faintly visible in the background. The bridge itself, constructed of wood planks and thin tree trunks, was built by local John Newman.

Smiley's Grist Mill at Riverside, on Seven Mile Brook, is located just below the bridge on the mill road. It was operated by Ira Smiley and torn down in 1904. At one time, this building was a shoe peg factory. The "Smiley Place," where Ira lived for many years, was nearby and was later occupied by his son-in-law Eugene Baker.

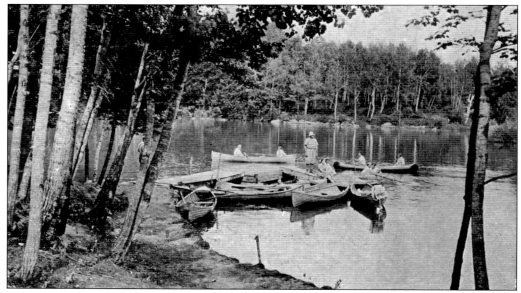

This postcard reads, "Pleasant Point Cottages is located on the shores of Webber Lake in East Vassalboro." It was made up of six cottages and seven- and eight-room structures; the buildings were fully equipped, offering bathtubs and showers with hot and cold water. Other amenities included garages, boats, screened piazzas, and ice and fuel supplies. Farm products and groceries would be delivered right to one's door as well.

Tilton Lane was named for William Tilton Bussell. Around 1930, Ivian Perley purchased a section of shoreline and built many cottages along Webber Pond. After family divorces, many of these cottages were sold outside of the family. The Tilton Lane Road Association, responsible for all cottages on Tilton Lane, still functions to this day and holds its yearly meeting each Fourth of July weekend.

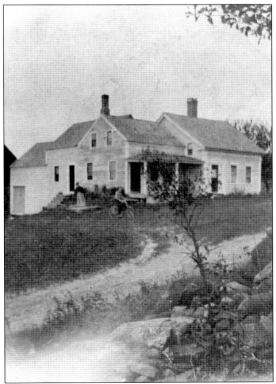

This photograph shows a home at the foot of Nelson Road, near the intersection of that road and old Route 202. The property was owned by Nina Pierce Mason, formerly of East Vassalboro. This was the home of Everett Melvin Whitehouse, Nina's grandfather, who was a captain in the Civil War. The person on the bicycle is probably Daniel Mason, Nina's cousin.

The Webber Family Cemetery is located on the Cushnoc Road in Riverside near the river, on the property later owned by Ian and Ann MacKinnon. This grave is of Charles Webber, a Revolutionary soldier, an early settler, and the first treasurer of Vassalboro. This photograph was taken in the early 1960s. The cemetery had been damaged by lumbering and vandalism.

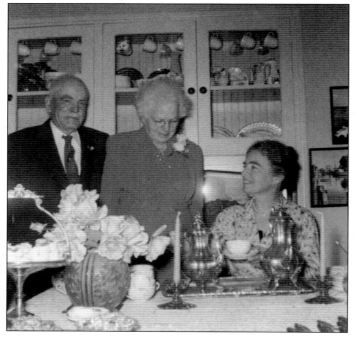

This photograph is of the 58th wedding anniversary of Edward O. Brown (1871-1959) and Jessie M. Brown (1882-1963). Their daughter, Julia Fossett Brown (1906-2002), is also pictured. Julia graduated from Oak Grove Seminary at the age of 16. Edward and Jessie formerly lived in the Riverside area, and both are buried in the Union Cemetery.

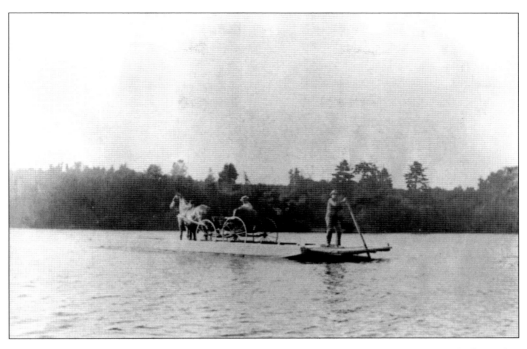

These photographs show the ferries from Riverside and Getchell's Corner. The shallow, flat-bottomed boats ran through the Kennebec River from the early 1900s to the mid-1930s. The ferry at Getchell's Corner was manned by Revell Pitts, and the ferry at Riverside was manned by Edwin Hughes. While these boats carried passengers and horses, they also carried goods for the stores of Vassalboro that had to be shipped from across the river. In 1931, the county commissioner voted to close the Riverside Ferry. The boats continued to travel the Kennebec for another two years before the last town records were shown with their mention in 1933.

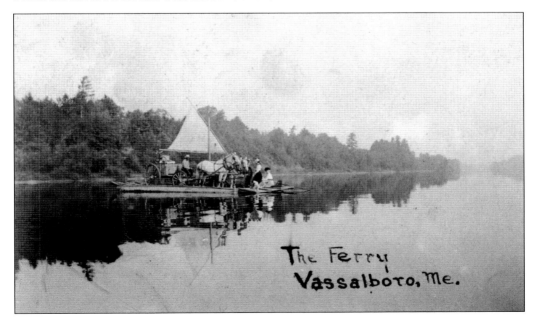

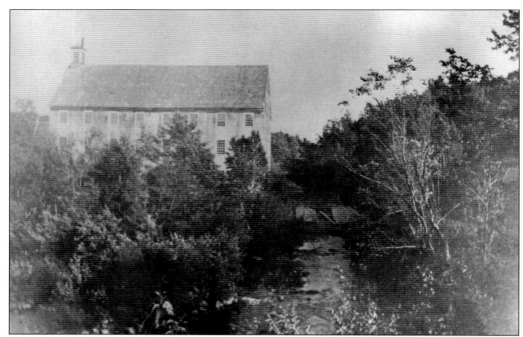
The Sash and Blind Factory and the Old Machine Shop on Seven Mile Brook were built in 1844 by Ira D. Sturgis and James Bridges for the manufacture of sashes, blinds, doors, and boxes. The first orange and lemon boxes ever exported from Maine were from this factory. It later operated as a machine shop and was torn down in the early 1900s.

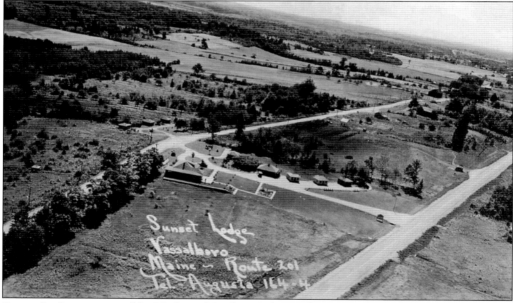
Sunset Lodge was owned by Merle and Pauline Cole. Merle was in the state police during World War II. He was charged with transporting a group of German prisoners of war (POWs) to the POW camp in Aroostook County. There was a blizzard that prevented safe travel, and he and the POWs spent the night in the cabins at the Sunset Lodge.

The E.L. Baker sawmill was once located at the mouth of Seven Mile Brook and was built by A.S. Bigelow and others around 1871. In 1887, it was purchased by Eugene L. Baker, who continued to operate the mill until the early 1920s. It was then sold for lumber and later destroyed by the town.

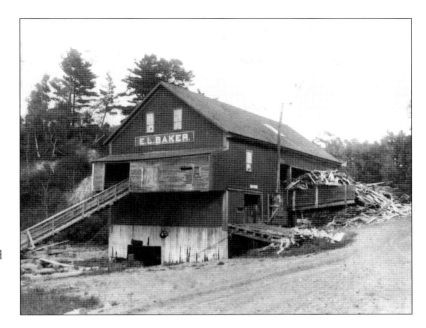

The Old Schoolhouse at "Slab City" once stood on the corner near the junction of Webber Pond Road and Paper Mill Hill Road (now discontinued). It was near the present homes of Gerald "Jerry" Dore and Robert Dow. The building was moved down behind Jerry Dore's place (the home in the background) near the farm bridge. Both the schoolhouse and the bridge are now gone.

This building on Webber Pond Road in Riverside was used as a waiting room, or station, for the area streetcar. Those living in the area came here to take advantage of the public transportation system, using the little hut as a small shelter while waiting for their car. This picture was taken around 1962.

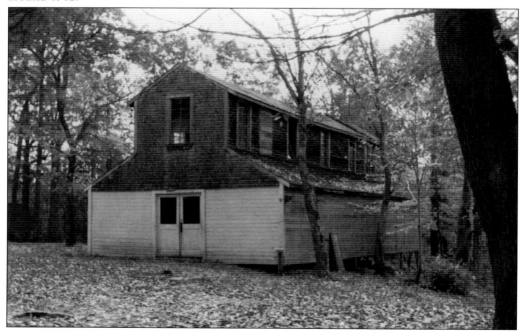

The Union Camp cafeteria was a part of the Union Camp Meeting Association. This was a camping site that was used as a church by the people living on Webber Pond Road in Vassalboro. Rev. Mark Stevens, George Pope, Joseph Buzzell, Daniel R. Preston, and LaForest McAllister, members of the China Camp Meeting Association, purchased the land and created the site.

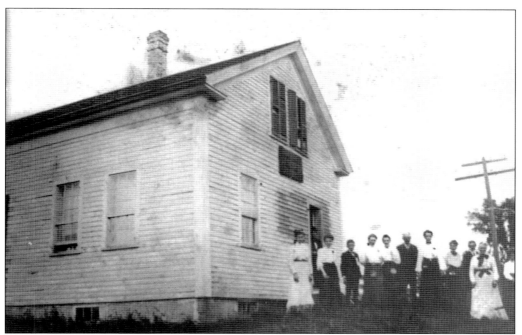

The Good Templars Hall in Riverside Vassalboro served as a social facility that served nonalcoholic beverages, campaigned for prohibition, "promoted education and self-help, and supported decent working conditions for working people." The Good Templars were founded in 1851. This photograph of the building was most likely taken sometime around 1905.

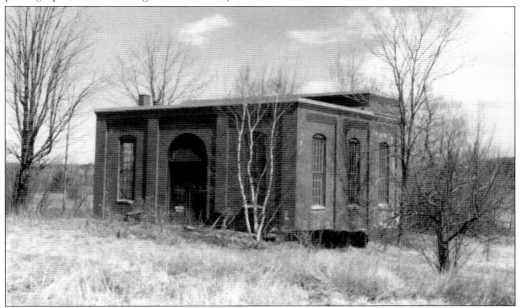

The old Androscoggin & Kennebec (A&K) Electric Car Line power station at Webber Pond was left abandoned before being bought by the Strong family. After their ownership, it was purchased by Mable Strong Lord and was bounced around to a string of other owners until it was finally demolished by the owner in 2023.

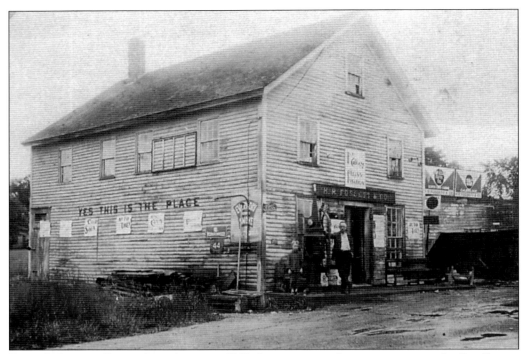

Fossett's Store in Riverside is shown in 1920. It was operated as a grocery store by Dr. George Randall from about 1860 to 1892, when it was sold to Henry R. Fossett, whose son joined him as a partner a few years later. The Riverside Post Office was in this building from 1856 until it was discontinued in 1911. The building eventually became the Riverside Congregational Parsonage and Parish House. The Fossetts stand next to the first gasoline pump between Waterville and Augusta. The building was torn down in the 1970s.

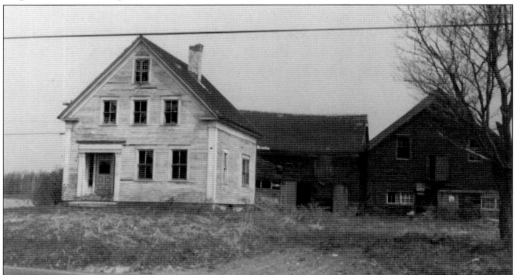

The "Gardiner Place" was the home of J. Perley Gardiner and is located on the corner of Webber Pond Road and Hannaford Hill Road. Gardiner's Crossing on the A&K Electric Car Line was named for this place. After standing vacant for many years, this place was burned by the town.

The Farwell House has also been known as "the Farwell Mansion," "Hilltop Manor," and "Kennebec Pillars." This Georgian Revival home was built in 1841 by Capt. Ebenezer Farwell for his wife as a wedding gift. Farwell was a slaver who was killed in a revolt in Africa after building the home. Neither of the Farwells ever lived there, and it was purchased sometime in the 1840s by John Newell.

Joseph Reed was the great-grandfather of Riverside's Norman E. Fossett. He was born in 1815 and married Frances Homans in 1840. Reed died in 1899 and was buried in the Union Cemetery. He had lived on Old County Road in the house that was later owned (in 1988) by David Shepherd.

This photograph of the Maine Central Railroad Station at Riverside in Vassalboro was taken sometime in the early 1900s. The station was not far from the ferry landing, so ferry passengers from Sidney could easily access the train if they were traveling north or south.

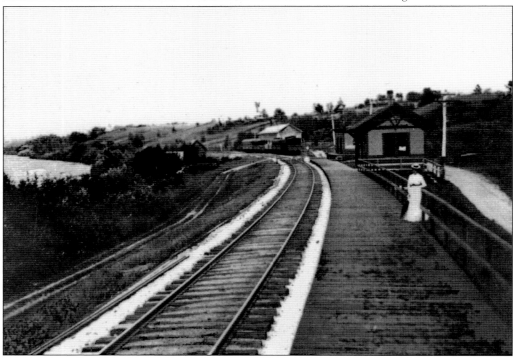

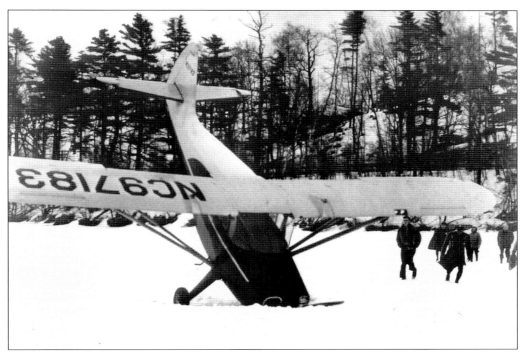

On March 15, 1948, a plane carrying presidential candidate Sen. Robert Taft of Ohio and Sen. Owen Brewster of Maine had to land on the frozen Kennebec River when the plane's engine failed. The three men had to walk about half a mile through deep snow to reach a telephone. Maine governor Horace A. Hildreth sent his car to pick up the men and take them to Bangor for a speaking engagement.

This house was not the first ever built in Riverside, but it is believed to be the oldest still standing on the old Town Landing Road, off the old Federal Road and behind the Pellerin farm. It had many occupants, but for many years, it was occupied by the Henderson family. The car probably belonged to them.

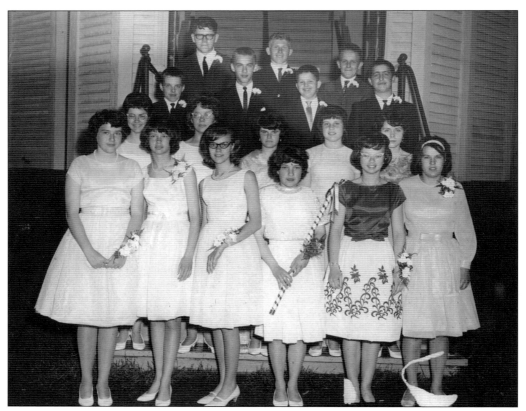

This photograph shows the Riverside School class of 1965. The names are written from left to right and include (first row) unidentified, Jill Underwood, Elizabeth Bailey, Kathleen Rowe, Linda Dalbeck, and Isla Taylor; (second row) Pamela Clark, Patricia Hanson, unidentified, Barbara Ellis, and Linda Gerard; (third row) David Gould, Laurence Albee, unidentified, and Arthur Pares; (fourth row) three unidentified. The principal at the time was Muriel Roth.

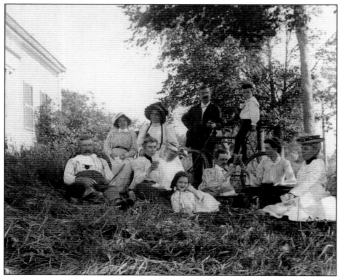

This is a snapshot taken at Riverside in 1901. It depicts a family enjoying a picnic in comfortable weather. Note the personality shown on each person's face. The people are identified as, from left to right, Mr. Rowe, Mrs. Reynolds, Miss Howe, Miss Norwell, Angela Sylvester, Gertrude Sylvester, Philip Sylvester, Mr. Reynolds, Mrs. Rowe, and Bertha Nowell.

About the Organization

The Vassalboro Historical Society was incorporated in 1963 and remains a fascinating repository for Vassalboro items. The museum is housed in the former East Vassalboro Grammar School, which serves as a wonderful display space in the upper rooms and storage in the lower rooms. The society offers bimonthly programs of interest to the community and is open each Monday and Tuesday from 9:00 a.m. to 1:00 p.m. and the second and fourth Sundays of each month from 1:00 p.m. to 4:00 p.m. The library holds resources for genealogical researchers and photo albums for browsers, while indexed scrapbooks provide a glimpse of the past through newspaper clippings.

The museum collection is comprised of items from or about Vassalboro residents or items made in Vassalboro. Displays in the front room are changed every two or three years. The society hopes that you will stop by for a visit and share your Vassalboro stories or artifacts or learn about those housed in this wonderful building.

Discover Thousands of Local History Books
Featuring Millions of Vintage Images

Arcadia Publishing, the leading local history publisher in the United States, is committed to making history accessible and meaningful through publishing books that celebrate and preserve the heritage of America's people and places.

Find more books like this at
www.arcadiapublishing.com

Search for your hometown history, your old stomping grounds, and even your favorite sports team.

Consistent with our mission to preserve history on a local level, this book was printed in South Carolina on American-made paper and manufactured entirely in the United States. Products carrying the accredited Forest Stewardship Council (FSC) label are printed on 100 percent FSC-certified paper.